W9-AWZ-869

Colour for the Artist

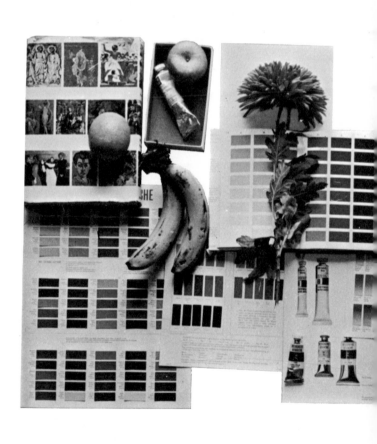

Colour
for the Artist
Hans Schwarz

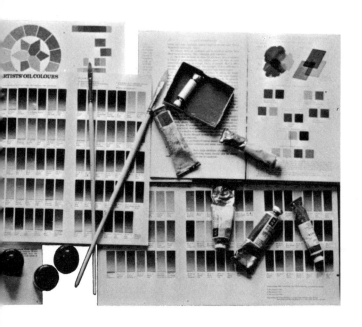

Studio Vista, London
Taplinger/Pentalic, New York

First published in the United States in 1980 by
TAPLINGER PUBLISHING CO., INC.
New York, New York

Printed in Holland

Library of Congress Catalog Card Number: 79-56605

ISBN 0-8008-1726-5

Contents

Introduction

In the 19th century colour theories and an interest in optics replaced anatomy and perspective as the centre of an artist's study and preoccupation. Colour and the techniques of painting were at the hub of the changes that have taken place in the last hundred years.

The reason, I think, is this. Originality is the quality, above all others, that modern artists strive for. Colour is personal and subjective. So is the way we handle pigments. The way we put them down is our hand-writing. It is therefore within these fields that originality will manifest itself most clearly.

Colour in nature is an unending source of wonder and delight. The constant changes of light, the brilliance of sunlit colours, the fierce subtleties of sunsets are an inspiration to every artist. We all know this feeling: How marvellous, I must do something about this, I must paint it! This urge is more important than the actual colours that triggered off the feeling.

It is the excitement and the newness of the Impressionists' discoveries that are more important than the optical and scientific discoveries underlying them. They were great artists not because of the fact that they saw violet shadows, but because they were the first to see them. The 'Eureka' is more important than the bath-water.

We must make our own discoveries, however humble, to get life into our work. Our paintings are worth looking at only for what we put into them of ourselves, not what we get out of the past, theory, or even nature.

Colour can be discussed from the purely scientific, physical and optical point of view. But this, I believe, is only of very limited use to the artist. (I have kept that part of the book to a minimum, and you are not going to be a worse artist if you skip it completely.) What is far more important is colour as a means of personal expression.

In spite of colour being so much a matter of personal taste and feeling, more can be taught and more useful information given about it, than about any other part of a painter's training.

A few painters are born with a magnificent sense of colour. They instinctively use original and vital colour. Most of us are not so lucky. Sometimes we feel that our colour comes right, but often, however hard we try, it just doesn't come off. We can

also get stuck in a rut and not know how to stop repeating much the same colour scheme every time we paint a picture.

I hope that the information in this book and the exercises I suggest will help you to be successful more often. I also hope that it will help you to use colour more adventurously. If, as well, it makes you look at other painters' work with more under-standing and enjoyment, it will have fulfilled its purpose.

You may well disagree with some of my ideas and conclusions. Please blame this on the fact that colour appreciation is so personal, that I can only state what I myself feel to be true.

The whole of the book is concerned with colour. But don't let us over-exaggerate the importance of colour. There can be art without it. The lack of colour does not make a master drawing less of a work of art. *Mona Lisa,* near monochrome now, can never have been colourful. Picasso's *Guernica*, possibly the most profound painting of this century, is in black and white.

1 What is colour?

In 1666 Sir Isaac Newton discovered that white light—sunlight—could be split into segments of coloured light by means of a glass prism. He decided that these component colours were violet, indigo, blue, green, yellow, orange and red.

More has been discovered in the 300 years since then. It has been realised that this visible band of light and colour—the spectrum—is only a tiny segment of the waves which travel at the speed of light; from X-rays to long radio waves.

We are here only concerned with colour, the visible spectrum. Sunlight gives the broadest spread, the widest spectrum. Most electric light is deficient in blue light and therefore seems yellow-tinged. Some fluorescent strip-lights are deficient in orange and therefore give a blueish, cold light.

A rainbow is sunlight split into the colours of the spectrum by rain-drops acting as prisms. The bevelled edge of a mirror can do the same. Many colour effects are related to this breaking up of white light into the spectrum. The colours of oil patches on water, butterflies' wings, soap bubbles, mother-of-pearl, the sheen on a starling's back, all these are instances of the effect of splitting light and not of truly coloured surfaces.

Newton's spectrum of seven distinct and nameable colours is in fact a continuous band, one colour imperceptibly merging into the next. There is no point on this band where one can say—here yellow stops and orange begins. But the decision as to where each colour has its centre is not arbitrary. There are three pure colours—the primaries.

Confusion is likely to set in here. The three primaries are different colours whether one speaks about light—that is, transmitted colour, or the colour of an object—reflected colour. Remember, we are dealing now with coloured light.

It is found that a combination of crimson, ultramarine and blue-green beams of light will produce the whole visible spectrum. If overlapping beams of these coloured lights are projected on a white screen, a further colour appears where any two overlap (fig. 1). Yellow is thus made by red and green, magenta (a red-violet) by red and blue, and a cold blue by blue and green. These are the secondary colours, lighter both in tone and apparent weight than the primaries. At the centre, where all three primaries overlap, white light is the result.

Recent developments in colour photography, television and colour printing have produced new knowledge—and confusion. A drum, divided into the colours of the spectrum, will appear red and green when spun one way, orange and blue when rotated the other. Yellow and blue alternating stripes will look white and black when seen from a certain distance. Black and white stripes, when seen through binoculars, are sometimes violet and orange edged. The spectrum colours, when mixed together as pigments, make black, yet the same colours, when painted as segments on a disc and spun, will appear near-white.

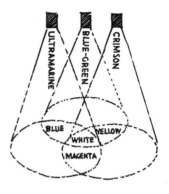

Fig. 1

Conflicting evidence points to the existence of 2, 3, 4, 7 or even only one primary colour. It has been found possible to produce the whole spectrum by projecting a black and white photographic slide with one colour filter only—that colour filter can be either red *or* green—plus a projection with white light.

Perceived colour

Light and colour can be measured by instruments. They can be translated into charts and statistics, but the sensations of light and colour can only be appreciated through our eyes.

We are aware of colour and light by means of a series of cones and rods in the retina. Rods perceive tones only, a monochrome scale from light to dark. Cones are colour perceptors. There are probably three series of them in the eye; one is sensitive to red, one to green and one to violet. This seems a further argument for the existence of three primary colours, even if these three are slightly different again.

Normal eyes can see the incredible number of ten million shades of tone and colour between dazzling sun and deepest night.

At night or in dim light only the rod perceptors in the retina are stimulated (the cones are less sensitive and need more light

to function), so we see then in a largely monochrome scale.

This has a practical application for the artist. If you want to ignore colours and see only the relative tones of either nature or your painting, half-close your eyes. This will reduce the amount of light reaching the retina, thereby putting the cones out of action. A so-called Claude-glass, a blackened mirror, will have the same effect—eliminating colour and clarifying tonal relationship. The mirror was so named because nature reflected in it takes on the appearance of a painting by Claude Lorrain, the 17th-century landscape painter.

Some people don't need these devices to see tonally: they are colourblind. Ten per cent of all men (it is rare to find a colourblind woman) are more or less insensitive to colour. It ranges from a slight deficiency in distinguishing between certain hues of red to an extreme, where red and green look alike. Blue and brown are indistinguishable. Only the relative tones of objects identify them in a black and white world.

Reflected colour

We can see the source of light, whether it is the sun or a cigarette lighter, but the light that eminates from that source is invisible. We cannot see actual sun-rays, only dust or water droplets lit by the sun. It is colour reflected from surfaces that makes one aware of light. The surface can be a page of this book, or the sky where fine particles in the atmosphere reflect blue light.

The more of the spectrum a surface reflects, the nearer white it will look. The more it absorbs the nearer to black will it appear. Grass looks green because it reflects only the green part of the spectrum, absorbing all others. A buttercup absorbs all colours except those which produce the effect of 'yellow'.

2 Seeing colour

Sir Isaac Newton saw seven primaries. So did Ostwald. Munsell decided on five. But whatever scientists decide, there are three for painters—yellow, red and blue.

They are indivisible. Yellow cannot be mixed from other pigments, nor can red or blue. I write of mixing pigments now, a matter entirely different from coloured light in the previous chapter.

The yellow, red and blue of the colour circle (fig. 4), balance finely between their neighbours: yellow, neither green nor orange tinted, red without trace of orange or violet, and blue kept free of violet or green on either side. Also (and this applies to all colours in the colour circle) they must be light enough not to contain black, and deep enough to escape a bleached look, which would imply the addition of white.

Equidistant from each other, the three primaries face their complementary secondary colours. Opposite yellow is violet, which is half way between a red and blue. Opposite red is green, an amalgam of yellow and blue. Opposite blue is orange, a mixture of yellow and red.

To complete our circle of <u>twelve colours</u>, each pair of these six neighbours has a further colour between them. Between yellow and orange there is yellow-orange; between orange and red, red-orange; between red and violet, red-violet; between violet and blue, blue-violet; between blue and green, blue-green, and between green and yellow, yellow-green.

If you wish to construct your own colour circle, my experience in the one reproduced in fig. 4 may be of use. There is no deep significance in the design I chose, but it shows clearly the

Fig. 2

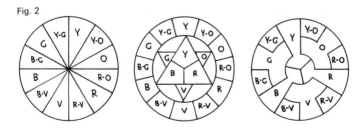

relationship between primaries, secondaries and sub-secondaries (I am reserving the term *tertiary* for colours containing elements of all three primaries).

Fig. 2 would be suitable alternative patterns for the circle. The initials refer to individual colours: yellow, orange, red, violet, blue, green.

I used gouache. Watercolour or coloured inks may be more brilliant, but gouache is more easily applied as a flat area and intensity is more easily controlled.

The circle of the original is about 9 in. across. Now for the actual colours:

Yellow. Cadmium Yellow Pale (Spectrum Yellow could be used instead).

Yellow-Orange. Cadmium Yellow Deep and a spot of Cadmium Orange. Cadmium Yellow Pale is too light. It would introduce a trace of white—as great an enemy of brilliance as black.

Orange is Cadmium Orange.

Red-Orange. I tried mixing Cadmium Orange and Cadmium Red Deep; this made too dull a colour. So I used Vermilion with a touch of Cadmium Orange. Orange Lake Deep or Scarlet Lake would probably be equally successful.

Red. Cadmium Red Deep with Cadmium Orange made too dark a colour, so I used Vermilion and a little Magenta. Spectrum Red would give much the same result.

Red-Violet. Magenta and a little Spectrum Violet. Extremely brilliant colours, but due to their transparency difficult to put on flat.

Violet. Spectrum Violet, in spite of its name, seemed too blue, so I added a little Magenta.

Blue-Violet. Ultramarine and a little Spectrum Violet.

Blue. Winsor Blue (another name for Monastral Blue) and white. There are several colours whose full brilliance only shows when they are lightened, either by adding white or by being used as a wash. I have said that white is the death of brilliance, but these colours are in the cold range and white paint only subdues warm colours by its own blue tinge.

Blue-Green. Viridian, Winsor Blue and a little white.

Green. Viridian and Lemon Yellow; Lemon rather than Cadmium Yellow which is too warm for a sharp green. This colour again was difficult to apply as a flat coat, as both constituents are semi-transparent. Permanent Green may be preferable.

14

Yellow-Green. Lemon Yellow and a very little Viridian. Yellow is the most vulnerable primary colour; the least touch of any other colour makes it change character.

Colour plates are hardly ever true to the original, so don't take fig. 4 as necessarily faithful to mine. (It's nice to be able to blame the printer for any shortcomings.) So, do not copy the colours of my colour circle. Just try to make the primaries as yellow, as red, as blue as possible, and the other colours as equidistant from each other as you can.

The three primary colours, combined in equal parts, theoretically produce black. But pigments are never pure colours, nor are they of equal strength, (this does not refer to their visual impact, but to their covering power). At best, a mixture of the three will make a dark grey. Again, theoretically, an equal mixture of any pair of complementaries makes black.

Not only the primaries and secondaries have complementary colours. Every colour, whether bright or dull, light or dark, has a complementary colour. The duller the colour is, the nearer to itself will be its complementary. A warm grey will have a cool grey as its complementary. Only an absolutely neutral grey will be without a complementary colour.

Generally, colours are considered to have three characteristics — but unfortunately experts don't agree on what to call them.
 On one they are agreed, however: *Hue,* the quality which distinguishes one colour from another—redness, greenness, greyness even.
 Then there is a quality called tone, luminosity, brightness or value. This is the degree of lightness or darkness of any colour; where it comes on a purely tonal scale between white and black. I think *Tone* is the best word to describe this.
 Third, there is what is variously called chroma, saturation or intensity. And I think the word *Intensity* best describes this quality. The stronger, brighter, more brilliant a colour is, the higher its intensity. At its peak it is described as saturated. That means it can't go any further. Any addition would deepen its *saturated* tone, but it would lose in brilliance and intensity. The intensity of any colour is the distance it is from a neutral black and white scale.

15

The red in fig. 5 is the same *hue* throughout. Its *tone* keeps constant only on the diagonal from top left to bottom right. The *intensity* is at its strongest in the rectangle at top left and gets weaker—or lower—in all directions by being diluted with either white or black or both.

This is one of a series of colour mixing exercises, which will help you to appreciate the potentials of your palette. I carried them out in gouache on white watercolour paper. They could be done in oils or watercolours:

Draw 16 rectangles, in a 4 x 4 grid (figs. 3 and 5), each one about 1 in. deep. Fill in the one top left with full strength colour. I used Cadmium Red. Then mix white with it to the palest possible shade which still retains some of the character of the original colour. Put this pale version in the bottom left rectangle. Now mix black with the original colour to the darkest possible shade. This goes into the top right corner. These are your three extremes.

Proceed to fill the whole grid according to fig. 3. C stands

Fig. 3

C	C+1B	C+2B	C+3B
C+1W	C+1W+1B	C+1W+2B	C+1W+3B
C+2W	C+2W+1B	C+2W+2B	C+2W+3B
C+3W	C+3W+1B	C+3W+2B	C+3W+3B

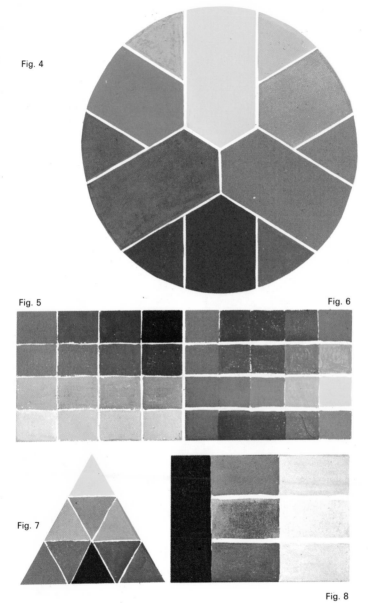

Fig. 4

Fig. 5

Fig. 6

Fig. 7

Fig. 8

17

for the original colour, 1, 2, 3, B and 1, 2, 3, W for additional black and white. Try to make the gradations even, so that there are no sudden jumps between any two rectangles.

This exercise can (and should) be carried out with all the colours of your palette—not only primaries and secondaries.

Only the blues more or less retain their character when white is mixed with them. If you carry out this exercise you will find that reds turn purple, yellows become chalky, greens will turn towards blue, so will violet.

To explore the distortion which takes place when colours are lightened with white, this exercise, figs. 8 and 9, was devised.

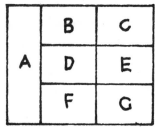

Fig. 9

The vertical bar at the left is full strength Burnt Umber. The diagram, fig. 9, shows the procedure. Panels D and E are the original colour, progressively lightened as washes. (If you do these exercises in oils, use turps to thin them.) F and G are lightened with white only, taking care to match the *tones* of D and E. As fig. 8 shows, the *hue* has become greatly distorted.

In B and C the *hues*, as well as the *tones*, of D and E are matched. For panel B Burnt Umber, Winsor Orange and white was used. Panel C consists of Winsor Orange, Cadmium Yellow, white and only the tiniest touch of Burnt Umber.

This exercise, again, should be carried out with a variety of colours.

The last two exercises were concerned with tone and intensity within single colours. Now we come to exercises which involve several colours.

Each of the four bars in the colour plate, fig. 6, represents the interaction of two colours: red and blue, red and green, blue and yellow, blue and orange. The colour in the left-hand panel is by gradual intermixture turned into the colour of the right-hand panel. The diagram, fig. 10, shows how. R stands for one colour, B for the other. This exercise can be done with any combination of two colours. You will find that even if you use

supposedly pure primaries, the resulting secondary colours in the centre panel will fall short in brilliance of the green, orange or violet you can squeeze out of a tube.

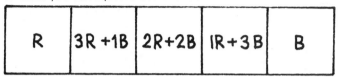

R	3R +1B	2R+2B	lR+3B	B

Fig. 10

Colour plate, fig. 7, and this diagram, fig. 11, show a more complex colour mixing exercise. But it looks more complicated than it really is. The corner triangles, A, B, C, are yellow, blue and red. Then D (orange) is mixed from A and C; E (green) from A and B; F (violet) from B and C. Finally, G is mixed from D and E; H from E and F; I from F and D.

Fig. 11

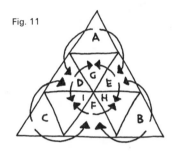

Care must be taken all along to mix colours which are equidistant from their parents.

The three final colours, G, H, I, are surprisingly similar in hue and tone. But it is not really so odd if you consider that:

G is two parts yellow, one part red, one part blue.

H is two parts blue, one part yellow, one part red.

I is two parts red, one part yellow, one part blue.

Their compositions are similar. All that distinguishes them is that each has one quarter more of one of the primaries in it. Here we have used the three primaries. A secondary colour can be substituted for one of them. Nine triangles can then be constructed:

Red	Yellow	Orange	Red	Blue	Green
Red	Yellow	Violet	Blue	Yellow	Orange
Red	Yellow	Green	Blue	Yellow	Violet
Red	Blue	Orange	Blue	Yellow	Green
Red	Blue	Violet			

It is agreed that colours have specific qualities and that these are responsible for particular kinds of contrasts. But no two

19

writers agree on the exact number or on what to call them. The following is my personal list. It could be argued that some of the headings, such as *Contrast of shape* and *Contrast of texture* do not even describe characteristics inherent in the colours themselves.

Light/dark contrast

Every colour in the colour circle has a tonal depth at which it is most itself. Yellow is the lightest, then orange, then red and green—they are about equal in tone—then blue and finally violet, the darkest. Fig. 12 is a scale of ten tones, from near-white to near-black. The colours are placed against the section which most nearly approximates to the tone at which the colour's intensity is at its greatest.

Colours can be lightened and still keep their identity—notwithstanding the fact that light red is called *pink*. All of them can also be darkened, but to varying degrees. Yellow is the least adaptable. Try to darken it and it becomes green or orange. Orange, when darkened, soon turns into brown. Red will tolerate only a certain amount of darkening before it turns violet or brown. But green, blue and violet stay themselves till they can be called black.

All colours can be reduced to a tonal scale. Every black and white reproduction of however colourful a painting, every snapshot or newspaper photograph simplifies and reduces all colour to a single tonal range.

Fig. 12

Complementary contrast

I am sceptical about theories of harmony and beauty based on scientific foundation. But it is a fact that complementary colours will balance and harmonize visually according to their light intensity and their wavelength. Fig. 13 shows the area each colour needs to reflect a given amount of light. Yellow, the lightest, needs three units, orange needs four, red and green six each, blue needs eight, and violet, the darkest, needs three times as much as yellow— nine units. These are also the relative sizes at which complementary contrast is usually most effective and harmonious (fig. 14).

Fig. 13

Fig. 14

Cool/warm contrast

Things get 'red-hot'. You can be 'blue with cold'. Water (blue or green) is cool, sand (yellow) is warm. Our feelings about colour temperatures are based on common experience. On the whole, blue is cold, red and yellow warm. But subtle and fine distinctions are made. A purplish red is clearly colder than one only a little more orange. Emerald green is colder than violet, yet the green can contain less blue. Theoretically, therefore, it ought to be the warmer colour.

Closely linked to these sensations of temperature are those of weight and density. The warm colours, reds, orange and yellow, tend to be dense and weighty. But a further element in these feelings is the degree of intensity or purity of a colour. The further a colour is from being a pure primary or secondary, the duller it is, the denser it becomes. For example turquoise blue is very much lighter in weight than a terracotta red. A sharp violet is less dense than a sage-green.

It is these qualities, which suggest meanings beyond the actual colour, that make colour such a powerful instrument in the hands of the artist.

Contrast of distance

Closely linked to temperature and weight is the feeling of distance that colours convey. Cool colours recede, warm colours come forward. Yet intensity of colour can greatly affect this. A saturated ultramarine appears closer than a pale orange. Strength of tone by itself can give a feeling of relative distance. The darker the tone, the more readily will it come forward (fig. 15).

Fig. 15

Simultaneous contrast

This is the most important in my list of contrasts. Wherever two colours come together, simultaneous contrast plays a part. Indeed, all the colours in a painting will act upon each other, setting up a whole range of stresses and relationships.

One would think that the nearer colours come to being true complementaries, the greater would be their mutual enhancement. But the most noticeable simultaneous contrast occurs when a strong colour is next to a neutral grey. The grey will seem to take on a definite complementary tinge of the brilliant colour. Against yellow the grey will look violet-tinged, against red it will appear greenish.

Brilliant colours need not be involved. Subtle and subdued colours can acquire force through simultaneous contrast. A brilliant white makes a duller white look grey.

The exercise in fig. 16 explores simultaneous contrast. In 36 squares all primaries and secondaries are juxtaposed against each other and against medium grey. The squares should have sides of about 2 in. Inside squares should be no less than $\frac{1}{2}$ in. a side. In the diagram initials again stand for the individual colours. Grey is indicated by a grey square.

22

As with all other exercises in this chapter, keep colours as flat and clean as possible. If you use gouache, don't get it too thin, it should just leave the loaded brush without dragging.

You will discover that the colour of the outside square is the

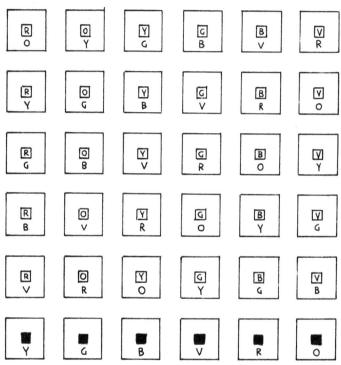

Fig. 16

dominant one, affecting the inside colour. Therefore each colour is used as both—as the dominant one when outside, and as the influenced one when in the centre.

Simultaneous contrast is responsible for most reactions we have to colour relationships—clashing or harmonising colour, colours that jostle, cancel or enhance each other, colours that sparkle, colours that chime together.

But what pleases one, another finds unpleasant. So, although our eyes and nerves react the same way to these phenomena, how we use them in our paintings will depend on personal taste and inclination.

Contrast of intensity

This is the effect that colours of different degrees of saturation have on each other. Fig. 5 could be taken as an example of this. But it also takes place between different hues; say, the effect that an intense green and a red, dulled by grey, have on each other. The more intense colour will probably dominate and expand at the expense of the weaker colour.

Contrast of shapes

A thin red line meandering across a blue area will look very different from the same amount of red as a circle on the blue. A soft, rounded shape feels different from a sharp, jagged shape, although the colour may be identical. The colours in a mosaic-like arrangement of spots play an entirely different part from the same colours used in large areas. In Chapter Six there is an exercise, 'Applying a colour scheme', which explores this aspect of colour.

Contrast of textures

A smoothly painted area will recede in space next to a roughly textured one of the same colour—which may read as a wall seen against the sky.

Varied treatment of the paint surface is one of the qualities found in many good paintings. A painting done in a repetitive technique, whether it is glassily smooth or insistently churned up pigment, can be rather boring.

The possible variations are infinite. Paint can be put on as a wash, as flat opaque paint, dragged, scraped or stippled, piled on with a palette knife, ridged with a comb or wiped on with a rag or a finger.

The colour plate, fig. 47, demonstrates several of the contrasts dealt with in this chapter.

The colour of the garment is only slightly warmer than the background. It is the contrast in texture, more than the slight difference in hue, that brings the figure forward. There is little three-dimensional modelling, but varied brushwork gives a sense of solidity.

In the head, the flicker of the paint is enhanced by simultaneous contrast.

Background and garment contrast as cool areas against the warm hues of head and hand. Here there is also an element of complementary contrast—blue against orange, red against green.

The dark area behind the lower part of the figure and the light strip in front provide dark–light contrast. Against it the rest of the painting seems transparent and luminous.

Let's conclude this chapter by dealing with black and white— the most powerful contrast. According to some, black and white are not even colours. But the very fact that they exist as pigments and can be used makes them colours—whether you like it or not.

As far as the painter is concerned, they are the purest colours. Each is all colours at the same time. _White light_ contains all colours, so does _black pigment_. And they assert this completeness. Other colours allow dilution towards light or dark and will bend towards their neighbours in the spectrum. Only black and white insist on purity. Add the slightest tinge of any other colour and they lose their identity. White becomes pink, grey, yellow etc. Black turns blue, violet, brown or green. There is no 'dark white' or 'light black'.

Black and white are the extremes of tone. Nothing can be lighter than white, darker than black. They are the ultimate and must be used judiciously.

Drawings by Rembrandt or Beardsley show how much colour there is in black and white. Op-painters like Vasarely or Bridget Riley demonstrate the power and life of black and white.

A reminder. Throughout I refer to red, yellow and blue as _primaries_; mixtures between two primaries—orange, green or violet—as _secondaries_; and muted colours (those that need elements of all three primaries) as _tertiaries_.

3 Pigments and technique

This book is about colour seen in nature and about the colour you put down on canvas, board or paper. It is not about the techniques of painting, but pigments and their qualities come within its scope.

Every painting consists of pigments and of a support—paper, board, canvas, hardboard, wood etc.—which is either used as it comes or prepared by smoothing it, colouring it and stopping its absorbency before painting on it.

Pigments are coloured powders mixed with a binding substance—oil in oil colours, gum in watercolours and gouache, a plastic in acrylic colours, emulsion and polymer paints. There are other techniques which use egg, casein, size or wax.

To apply them to the support, pigments are usually thinned— with turps or white spirit (mineral spirits) for oil paints, water for the others. To give oils body and gloss, particularly if they are used thinly, linseed oil, varnish or a painting medium, such as megilp, can be added. There are mediums available for acrylic colours. Gouache and watercolour painting mediums are not often used. Oils, gouache, acrylic pigments are opaque; watercolours and coloured inks are transparent. With opaque pigments, pale shades are produced by an admixture of white. With transparent pigments white (or tinted) paper provides the lightest shade. If thinned with the appropriate medium, opaque pigments also can be more or less successfully used for transparent washes.

In oil painting, washes of dark, transparent colours over lighter (generally opaque) colours are called glazes; washes of light colour (generally semi-opaque) over dark are scumbles. Glazes and scumbles are usually mixed with linseed oil or varnish to give them substance and depth.

Glazes can produce rich, glowing colours, which are impossible to equal in opaque colours. For instance, put a glaze of Alizarin Crimson over Yellow Ochre. There will be infinite variation of colour, due to the changes in the thickness of the glaze. It would be impossible to match by mixing the two pigments on the palette. Nor can the grey produced by a glaze of Burnt Sienna over dull green be matched by a mixed opaque grey. Again, the cool, cloudy effects of scumbles cannot be equalled with opaque paint.

At one time artists had to grind and mix their own pigments,

jealously guarding their composition. Colours had to be stored in jars under a film of water or in sheep's bladders which were pricked and the paint squeezed out when needed. At the beginning of the 19th century a glass syringe was used, a plunger forcing out the pigment. By then paints were manufactured commercially. Collapsible metal tubes were invented in 1824, making storage easy and use economical.

But the tradition of secrecy remained. So, many artists were ignorant of the risks inherent in the use of some colours. There were poisonous ones, there were colours which reacted disastrously on each other, by changing their hue. There were pigments which faded rapidly on exposure to daylight; others darkened. Some colours contained bitumen which, after a few years, made paintings done with them look like old roofing-felt.

In 1892 Winsor & Newton published a statement of policy, classifying colours in the order of their permanence and publishing their chemical composition. Since then all colour manufacturers have followed suit. We now have a wide selection of pigments which are permanent, constant in quality, and harmless. (There are still some poisonous pigments on every maker's list, but inocuous substitutes exist for them.)

New colours constantly come on to the market. Most of these are synthetic, replacing pigments made from plants, from animal substances or even semi-precious stones; such as Gamboge, Purple or Ultramarine.

In spite of their often cited secrets, nearly all the procedures of the old masters are well understood and could be repeated today. But their approach was so different from anything attempted or aimed at now, that their technique has only historical interest. It may be that a day will come when a revival of some of their methods will give life to a new movement, but that day is not here yet.

They, or rather their studio assistants, first prepared wooden panels with innumerable layers of glue and plaster (gesso). Then the design was carefully traced down. The painting was begun in near monochrome—until about the year 1470 in tempera, using egg or gum as a binding medium. The paintings were completed by adding brighter and stronger colours in oil glazes.

These involved techniques, the complex composition of some of their pigments (camel's urine was a constituent of some of them), hazards to health, impermanence of pigments, and early manufacturers' reluctance to divulge their methods, have com-

bined to surround oil painting and the very names of colours with a cloud of mystery. But every handiman who paints a garage door uses oil paint and isn't overawed by it.

Quoting Winsor & Newton's notes on the mixture of colours: '. . . Certain types of colour mixture have been regarded, by some authorities, as of doubtful stability . . . Now, however, as a result of several years of observation of such mixtures in various proportions, and under various conditions, we have satisfied ourselves that while the dire warnings may have been justified at one time . . . pigments as now made do not act upon one another in the way that was formerly feared, so that these particular mixtures can be used with confidence . . .'

There is however a note of caution: '. . . The performance of a colour is not . . . improved by mixing it with white (Lead, Zinc or Titanium White in oil colour, and Chinese White in water colour) or, in fact, by mixing it with other pigments, even permanent ones. If the colour is a durable one, it will probably suffer no injury, but any weakness in resistance to light and air is frequently accentuated by the dilution which is a necessary consequence of such admixture . . . There are cases in which colours act upon each other chemically when mixed together . . . Winsor Orange, Winsor Red and Scarlet Lake Oil Colours should not be used in the form of very pale tints with white. Such tints, particularly when the white is Flake White, tend to fade out, even in the dark.'

Here also, for the cautious, is a list of more or less poisonous pigments. They are safe in ordinary use, but brush-licking with watercolours and applying the oils with your fingers, is inadvisable.

First the oils:

Chrome Deep	Cinnabar Green Deep	Lemon Yellow
Chrome Green	Cobalt Violet	Magenta
Chrome Green Deep	Cremnitz White	Mauve Blue Shade
Chrome Green Light	Flake White	Mauve Red Shade
Chrome Lemon	Flesh Tint	Naples Yellow
Chrome Orange	Foundation White	Silver White
Chrome Yellow	Geranium Lake	Zinc Yellow
Cinnabar Green	Jaune Brilliant	

The water colours:

Chrome Deep	Chrome Yellow	Purple Lake
Chrome Lemon	Lemon Yellow	Rose Carthame
Chrome Orange	Mauve	

Winsor & Newton have a list of over 100 artist's oil and water colours. Most makers have lists of similar length.

About forty of the colours on these lists are marked as being absolutely permanent, most of the others are reasonably so— but to quote the catalogue: 'It is impossible to draw any hard and fast line between a "Durable" and a "Moderately Durable", or a "Moderately Durable" and a "Fugitive" colour. The arrangement is an arbitrary one . . . the terms have no meaning apart from some statement of the degrees of change and the duration of the exposures on which the distinctions are based.'

Some of the pigments are near-identical in colour, only their chemical composition differs. There are for instance ten different whites on the oil colour list. Others are tints made from a number of colours, i.e. Naples Yellow, which is made from Cadmium Yellow, Light Red, Yellow Ochre and Flake White. Or Flesh Tint, which is made from Naples Yellow (itself a mixture of four colours) plus Cadmium Red and more Flake White.

Some colours are so fugitive that even a painter without a great sense of his importance to posterity would hesitate to use them. There are pigments containing expensive ingredients making them up to ten times the price of the cheapest.

Most makers supply several qualities. There are *Artists*, *Economy* and *Students* oils and watercolours. *Poster Colours* are the cheap versions of gouache. There are short lists of colours in large tubes or tins at relatively low prices.

The cheaper lines are not ground as finely and some expensive ingredients may be replaced by somewhat inferior substitutes.

No maker would wish to mislead artists about the quality of his products and I am sure that whatever claims are made about the relative standards of pigments are to be trusted. But, from overcautiousness probably, most artists—myself included—buy Artists' colours, usually in the largest size tubes available.

Catalogues can be confusing. Colours may be grouped alphabetically, according to price, by hue in spectrum order or in order of permanence. Colour charts are the most useful aid in deciding what colours you wish to buy, but only use will show what a colour is capable of.

Most artists have about a dozen colours which form the basis of their work; a further six or so may be used from time to time. Painters will experiment with new pigments—from curiosity or a friend's recommendation—occasionally incorporating them into their standard palette.

Using a colour new to you can considerably affect your work. I was once given a few tubes of oil paint, among them a large one of Brown Madder, a purple-suffused brown, a colour I had not used previously. I tried it in the early stages of a painting instead of my usual Raw Umber to indicate tone. Now I saw areas, which I had been used to seeing in terms of tone only, as positive colour. It made me pay quite different regard to the tone-colour relationship. Incidentally I soon discarded Brown Madder, as on closer acquaintance I found it over-insistent and leading to mannerisms; but it had taught me something.

As we develop artistically our styles change and we will have to find new colours to suit this, probably discarding some old ones. Recently, for instance, my work has been getting brighter and I have incorporated Winsor Orange and Cobalt Violet in my palette.

All painters advise their students to use as few pigments as possible. But there will be some brilliant colours which it is impossible to mix with a restricted palette—sharp greens, violet and a luminous orange, for instance. Theoretically they are secondary colours, capable of being mixed from primaries. In practice you will need the actual pigments—green, violet, orange.

The following list of colours is primarily meant for oil painting, but will also be found suitable for gouache and water colour. The less essential colours, those which may only find occasional use, are printed in brackets.

(*Lemon Yellow*), durable, slightly poisonous. A pale, cool yellow, cheaper than Cadmium Yellow. The basic primary yellow lies between this and

Cadmium Yellow, a bright strong yellow, warmer than the above. None of the brilliant yellows, except Aurora Yellow which is transparent, are absolutely permanent.

(*Cadmium Orange*), durable. Chrome Orange and Winsor Orange are of similar character, but Chrome Orange is poisonous and Winsor Orange tends to fade if mixed with white. It is impossible to mix an orange as bright as these from yellow and red.

Cadmium Red, a strong, durable red, the basic red of the spectrum, a primary colour. Balanced finely between orange and violet. (It was Cadmium Red *Deep* which was too dark for the primary red in my colour circle.)

(*Alizarin Crimson*), durable, a deep, purple red, somewhat transparent, useful for glazes. Mixed with white makes a pucey-pink. Preferred by some painters to Cadmium Red as their standard red. It is cheaper too.

(*Winsor Violet*), durable, brilliant, transparent, the spectrum violet. It is cheaper than the opaque Permanent Mauve or Cobalt Violet, which is poisonous. As with orange, it is impossible to mix a brilliant violet from adjacent primaries—red and blue.

(*French Ultramarine*), durable, transparent. One of a range of Ultramarines: Brilliant, Light, Deep etc. They are synthetic colours. Pure Ultramarine, made from Lapis Lazuli, would be prohibitive in price. Only restorers and forgers, such as Van Meegeren when he painted 'Vermeers', are likely to use it now.

(*Cobalt Blue*), absolutely permanent, transparent. A colour near the spectrum primary blue. The standard blue of many artists. More expensive than Ultramarine, or

Prussian Blue, durable, transparent, deep. One of the cheap pigments. My standard blue. It will mix with yellows to a wide variety of greens, with reds to a reasonable violet. But use carefully, it is extremely powerful. Because of this you may well find that Cobalt Blue suits you better as your stand-by.

Viridian, an absolutely permanent, cool emerald green. One of the more expensive colours. Invaluable, not only as a green, but for cooling reds, pinks and browns. Hardly a portrait or life painting is done where Viridian is not used in the flesh tints. Another colour used by many for this purpose is

(*Terre Verte*), a duller, opaque green; much cheaper than Viridian. It is often used for the initial lay-in of paintings.

Yellow Ochre. This and the following are all earth colours, literally made from earths, either in their natural state or calcined. They are cheap and absolutely permanent. Yellow Ochre is opaque. A muted golden yellow.

(*Raw Sienna*), warmer than Yellow Ochre, transparent. Can be used (often abused, as it suffuses the painting with a flattering glow) for glazes. Some painters prefer it to Yellow Ochre in their basic palette.

(*Light Red*), is calcined Yellow Ochre. An overpowering red-

brown with great covering power—use sparingly. With Prussian Blue and white it makes a wide range of greys. Venetian Red and Indian Red are colours of similar strength and quality. Another pigment not unlike in hue is

Burnt Sienna, but it is gentler in use and darker. It is transparent and can be used for glazes.

Burnt Umber, a rich, very versatile brown. Often used for the lay-in of paintings. The more transparent Van Dyke Brown is of similar hue, but rather fugitive.

Fig. 17

Raw Umber, a cooler dark brown. Both this and Burnt Umber are pleasant colours and tend to be used too extensively as neutralising, toning and shading colours.

Ivory Black, absolutely permanent, made from calcined bones.

Flake White, durable, slightly poisonous. The standard white of most artists.

32

(*Titanium White*), the only completely permanent and non-poisonous white. It is also the most brilliant. But it is not as pleasant to use as some of the other whites.

(*Underpainting White*), is a little thinner. Even decorator's white undercoating can be used for some effects. (Many artists use decorator's colours in cans for their work, without finding them too liquid.)

White is the colour you use most of, so it is worth trying pigments of different character and consistency till you discover which suits you best.

Tubes of most of these colours are shown in fig. 17, giving their approximate relationship to the colour circle. The outer circle of earth colours shows where they, the muted colours, fit into the scheme.

In this list I have adhered to Winsor & Newton's colour names. Most of them are called the same by all makers, with the exception of colours containing the name Winsor.

Gouache

Oils are bound with oil, and turps or oil are used as a painting medium. Gouache has gum as a binding medium and only water is used in painting. Gouache is quick drying, so further layers of paint can soon be applied. But care must be taken. Subsequent over-painting may dissolve the lower layer of pigment and affect the colour you are putting on top.

Gouache, body colour, opaque watercolour, poster colour, are all much the same and only differ in quality. Like oil paint, they are meant to be used opaquely, although as with oil paint, washes and glazes are possible. The opacity of pigments varies, perhaps more than with oils. On my list only Cadmium Red, Yellow Ochre, Viridian, Burnt Umber, white and black have covering power comparable to the equivalent oil colour. Several colours—none on my list—stain. Being based on stains or dyes, they tend to bleed through subsequent layers of other colours. Only the interposing of an impervious film, such as black Indian Ink, will stop these colours grinning through.

33

Gouache is sold in tubes, jars or pans. In pans you have to work hard to dissolve a brushful of paint. It's bad for brushes, slows down your work and makes the mixing of reasonable amounts of paint near impossible.

Jars are useful if you use large quantities, but unless you are very careful never to dip a dirty brush into a jar, the paint in them tends to get dirty. Also, unless the jar gets used within a fairly short time, the paint dries and you either have to throw it away or scrub around the dry colour to get a meagre brushful. Gouache in tubes, fig. 18, dries eventually; but in years rather

Fig. 18

than months. I have in use tubes of gouache which I bought five or six years ago. Caps must always be screwed on firmly after use.

A tip about caps that seem to have become immovably stuck. Brute force will split the tube at the shoulder. Hold a lighted match for a few seconds under the cap and it will come off easily. The cap has to get hot, so use a rag to take it off.

Gouache can be used on any paper or board. There is no preparation necessary, as there is with oils, to make it less absorbent. It can be used straight from tube or jar, but generally gouache is thinned with water to a creamy consistency. If wet areas of paint are put down next to each other they tend to merge and run. This effect is often used deliberately. Gouache textures are shown in fig. 19.

Some colours, particularly if white is mixed with them, change tone and intensity several times in drying. A few seconds after putting it on in the intended shade the colour turns blotchily lighter, the white in it seeming to come to the surface. A little later the colour turns darker than you meant it to be; but in the end it dries lighter than you had hoped. To be sure of an exact colour you must let a sample dry completely.

Fig. 19

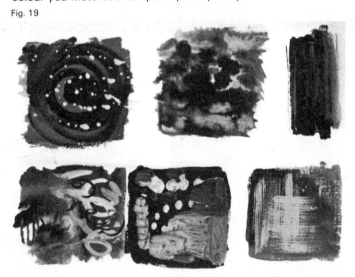

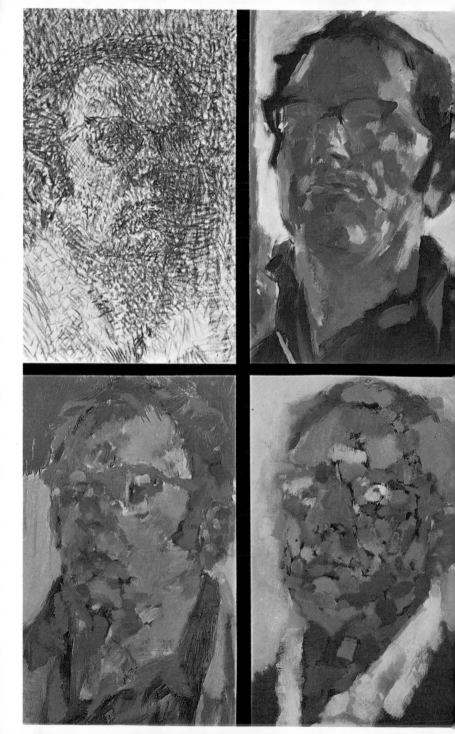

Gouache always dries matt, with a dusty, velvety surface which makes colours look lighter than they actually are. There are varnishes that can be used to give gloss and depth to gouache. I have never felt any need of them; I like the natural bloom of gouache.

The permanence of gouache compares unfavourably with that of oil pigments.

Acrylic colours

These pigments, which have become available in recent years, are not unlike gouache in character. As with gouache, water is the only medium necessary in most of the brands. The main difference is that once dry they cannot be dissolved. They form an extremely tough surface, never cracking or flaking. (Acrylic paint is used to spray automobile bodies.) If you let the paint dry in a brush, you might as well throw the brush away; you will never be able to clean it.

The even, bright flatness of acrylic has encouraged a contemporary school of precise, hard-edged abstract painting. These painters use masking-tape to define their areas of colour and several thin coats of acrylic, gradually building up to the desired density. All is planned, nothing is left to accident, in a technique comparable in deliberation to that of the old masters.

It is most effective used in this flat, impersonal way. I myself think that used as heavy impasto in an imitation of oil technique it looks cheap and nasty. The actual pigment is more transparent than oils or gouache and blobs of it look just what they are— lumps of plastic.

Acrylic can be used on absorbent surfaces: umprimed canvas, wood or hardboard, as well as paper.

A painting medium is available for acrylic, as for the other techniques. Mediums add body and strength to thinned paint (ideally, without affecting its colour), making it thicker and more easily controlled in working, tougher and glossy in drying.

Acrylic pigments have not been in use long enough to tell how permanent they are. All signs, however, point to their being at least as tough and long lasting as oils or gouache.

Even well capped, acrylic colours will set into a rubbery jelly in the tube within about a year, so they must be used fairly quickly. Cheap oil colours too may jellify in the tube within a few years. Only Artists' oil paints stay workable indefinitely. I

Fig. 20

have tubes that were first used twenty years ago and are still in perfect condition.

Fig. 21

Watercolours

Until now we have dealt with techniques where colours are mixed to the desired lightness by adding white pigment—the colour or tone of the ground not materially affecting the final painting.

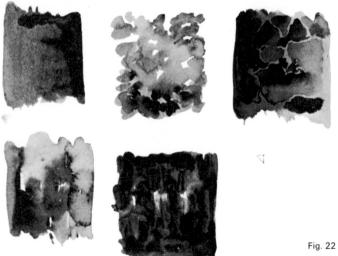

Fig. 22

But with watercolours, transparent washes of varying strengths use the light background—usually paper—to provide the equivalent of white. No part of the work can be lighter than the support. At one time tinted papers were popular for watercolour painting. I think this is too easy a way of ensuring harmony, akin to the use by the Victorians of brown varnish on oil paintings. It makes bright, positive colours impossible and belongs firmly to the days before the coming of Impressionism.

Painters like Kandinsky, Klee and Kokoschka have shown how the medium can be used in the 20th century. They show, in particular, how the white of the paper can be a positive colour and actively contribute. Sam Francis in the U.S. has shown more recently on a gigantic scale how impressive watercolour can be, with its merging, melting, liquid qualities. He has also used acrylic colours on canvas to similar effect.

Fig. 22 shows some watercolour textures, on hard, non-absorbent paper. The qualities of the paper can have a strong effect on the look of a watercolour painting.

Watercolours are sold in tubes (fig. 21), or in pans or cakes. Again I would advise buying them in tubes. Pans are more economical—too economical. The bother of loosening enough pigment from the pan tends to make one paint meanly and too pale, hardly ever using a brush fully charged with juicy paint. Watercolours in pans, containing some glycerine, are semi-moist. Cakes of watercolour, as originally made in the 18th century, are stone-dry and must be ground in water against a hard surface to loosen the particles, so making it even harder for the artist.

I would also advise against buying ready-fitted tin boxes of watercolours. They are expensive and either contain too many different colours or the wrong ones.

Coloured inks

I use this technique a lot and find it useful and enjoyable. So I may spend more space on it than perhaps it warrants. It has one drawback—the doubtful permanence of the inks.

Where catalogues are informative about the relative permanence of oils, gouache and watercolour, they keep a discreet silence about the permanence of waterproof inks (fig. 23). These inks

may not have been intended to be used by artists for work which is meant to last—though I'm not sure what else they were intended for.

Some time ago I exposed samples of coloured inks painted on strips of white paper to daylight in a south-facing window. To retain a control area I masked part of each strip with black paper. After only weeks some colours were visibly fading. After months they were markedly lighter, and after a year some colours, the reds in particular, were so pale as to have lost their identity. But in any case, in other media, the permanence of many colours is relative. In Winsor & Newton's *Note on the Permanence of Artists' Colours* it says: '. . . Unenlightened Artists may take the word "Permanent" to mean, in all cases, absolutely permanent, which it certainly does not . . . for instance . . . fairly strong Water Colour washes of the Alizarin Reds . . . Madder Lakes, Alizarin Carmines, Alizarin Scarlets, Alizarin Crimsons, Rose Madders, Ruby Madders, . . . on paper, and exposed . . . to . . . ordinary daylight, may (it is a conservative statement) lose 50 per cent of their strength in . . . ten years, and . . . will probably vanish in twenty . . . precisely the same may be said of fairly strong Oil Colour glazings.'

Being waterproof, these inks can be applied in successive layers, one wash over the other, without producing the muddy effect of several layers of watercolour. Splendidly rich, glowing colours are possible. This is not the technique for highly realistic subjects, but if your work is at all stylised and decorative,

Fig. 23

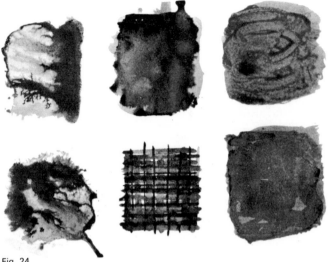

Fig. 24

coloured inks will suit you. They are also particularly useful in mixed techniques, with gouache, crayons, pen or collage.

Inks can be mixed with each other and thinned with water. For this the makers advise the use of distilled water or rain water filtered through blotting paper. For black Indian Ink they recommend you to add a few drops of ammonia to the water to make it alkaline.

I have always diluted inks with ordinary tap water. Occasionally the ink curdles, giving washes a sedimentary look. At other times, particularly with blue ink, water has a slightly jellifying effect. I don't mind, it adds to the textural interest. Fig. 24 and the colour plates on p. 77 show some of these effects.

I try and keep the ink in the bottles clean. Mixing and diluting takes place on saucers, but now and then brushes full of one colour get dipped into another; no ill effect seems to follow.

Inks are sold in bottles of varying capacities between $\frac{1}{2}$ oz. and 20 oz. I usually buy them in 1 oz. or 5 oz. bottles.

Although about twenty different colours are on the market, the following eight will serve to produce any the medium is capable of: Yellow, Orange, Crimson, Violet, Ultramarine, Prussian Blue, Viridian and Black.

41

Waterproof inks are dyes. There are no earth colours, and even though Yellow Ochre, Burnt Sienna and Burnt Umber are in the catalogue, these colours are easily duplicated by adding black ink to yellow, orange or red.

Coloured inks are very brilliant in hue. Remarkably bright colours result even from the intermixing of two secondary colours, colours which one would think would dull each other. Emerald and Violet, for instance, make a bright blue. The small amount of yellow in Emerald and red in Violet cancel each other, without greatly dimming the resulting colour.

Pastels, crayons, coloured pencils

Pastels are pure pigment, mixed with white chalk for paler shades and moulded into stick form. Containing no binding medium, they are very friable. Drawings done with them are fragile, liable to smudge and dust off. Fixative destroys some of their delicacy and bloom. They should be kept under glass.

Fig. 25

There are about 80 different colours or hues, each obtainable in from three to eight degrees of intensity ('0' the palest, '8' the deepest), which means that there are upwards of 500 distinct shades available. There is a bewildering variety. Apart from the usual colours, there are things like Red Grey, Pansy Violet, Lizard Green, Cold Brown, Sprinck's Olive and Neutral Orange— *and* you can get each one in about six tints.

As a beginner you will need between 20 and 30 pastels. Select your colours according to the subject you wish to draw with them. For a portrait you will need a range of pastels different from those you would use for landscape.

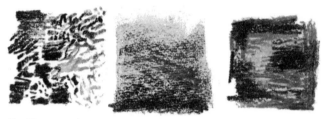

Fig. 26

The most usual support is neutral tinted paper. Pastels are opaque and, as with oil paint, in the finished work the colour of the ground is often completely eliminated. Each colour has to be put on separately. A little colour mixing is possible by drawing one colour into the other, but not by smudging, which deadens the surface and makes the drawing lose the natural bloom of pastels.

Pastels, too, are often used for sweet and weak-kneed portraits, particularly of children. Look at pastels by Degas, Toulouse-Lautrec or Vuillard if you want to see what the technique is capable of.

Pastels are respectable, but wax crayons and coloured pencils are usually thought of as kids' stuff. But recently wax crayons (or oil pastels as they are now called) have become popular. Lay-out artists and visualisers in advertising studios have been using them for some years and now painters have begun to experiment with them. The colours of oil pastels are stronger than those of traditional pastels and they produce more vigorous textures. Colours can be superimposed to interesting effect (fig. 26). In particular the harder varieties are less liable to smudge.

I prefer these in any case as they give a more defined and graphic line. At least 70 different colours are available, but a range of about 12, similar to the oil painting list I gave, would be enough to start with. Another good thing about them—they are cheap. A box of 60 different colours costs only about £2 ($4).

Coloured pencils too have come into wide use by artists, popularised by illustrators, who have used them for Art Nouveau and pseudo-naive illustrations, exploiting the scribbly and erratic textures small children get with them (fig. 27).

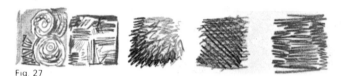

Fig. 27

This chapter has not exhausted the colour media available to you. Only some of the more usual ones have been dealt with. Here, briefly, are some of those I have not included.

Egg tempera, a traditional technique, is suited to fine and meticulous detail.

Encaustic painting, a technique used by the Romans 2000 years ago, is based on wax as the medium. Roman portraits done on mummy cases of the deceased are still in excellent condition.

PVC colours, available both in Great Britain and in the U.S., and other plastic-based pigments are not unlike acrylic. Pictures have been painted with decorators' emulsion paints. Distemper, which uses size as the medium, was Vuillard's favourite technique.

Coloured gummed papers can be used for collages; Matisse used this child's medium brilliantly when he was an old man. It is a technique well suited to colour experiments, as are coloured tissue-paper collages. Used in several layers these give subtle and unexpected effects. As there are more than 100 different tints available now, this is by no means a crude medium.

There are two kinds of powder colours: those that include a binding medium and need only be mixed with water, and more expensive, finely ground, pure pigments. To these the artist himself must add oil or whatever binding medium he wishes to use.

44

4 Colour in nature

It rained during the night. The September sky is pale, with thin cloud. The hills, two miles away, are light, closer in tone to the sky than to the fields in the foreground. The nearest meadow is sharp, rich green. Further fields look progressively greyer with distance. Dark hedges and elms frame the fields. Tones extend from the white, pale sky to the base of the nearest hedge, a rich black-violet.

The sun comes out. Suddenly the values shift. The meadow in sunlight is now vastly lighter than where the shadows from trees fall across it. This grass in shadow is now much nearer in tone to the near-black hedge. Yet the grass cannot actually have become darker than it was before the sun came out. If I had begun to paint this view before the sun appeared, I could not reconcile any of the tones or colours I put down then with what I see now.

Coming into a room from sunshine, the room appears dark. After a moment our eyes adjust and the room seems bright and well-lit. A light switched on in the room makes no appreciable difference to the illumination, the bulb itself is only a weak glimmer. After dark the 'weak glimmer' lights the room well enough—our eyes have adjusted.

Our eyes will always accept the lightest available tone as brilliant. Brightness is relative. White paper in a dimly lit room looks as *white* as it does in sunshine.

The white washing in fig. 28 was considerably darker than the dark clouds in the sky—but I only realised this after careful comparisons of the relative tones. Against the seemingly light green grass it had looked dazzling white. Within the sky itself there is a wide range of tones—between the sunlit surfaces of clouds and their dark undersides (which are still so much lighter than the washing). In the middle distance there is a sunlit field, golden green in colour. We know that any *colour* is bound to be darker than white, yet this field is also much lighter than the washing.

I am looking at this view through a white-painted window frame, but this white paint, seen against the landscape, is the same tone as the near-black hedge.

I tried to keep the tones correct and balanced within sky,

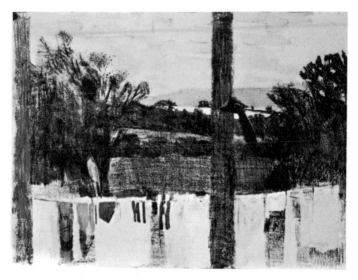

Fig. 28

sunlit field and washing. To indicate the impact of these light parts against fields, hedges and trees, I had to draw the fields in dark, near-black tones. It was a reasonably bright day, yet there is a feeling of dusk or thunder in the drawing. Trying to be literal, to be true to the tones in nature, I arrived at a vastly distorted image. What began as an attempt at objectively true tonal rendering ended as a proof of its impossibility. No true copy of nature is ever possible! We cannot get lighter than white paper, darker than black, more brilliant than the pigments in our paint box.

About the technique used in the drawing: it was done on white watercolour paper with black Conté crayon, black fountain pen ink and white gouache. Washes of clean water consolidated the textures of Conté crayon. White gouache quickly picks up black from the crayon. This and a little black ink makes the smooth, opaque greys. The black ink is also used as a wash, particularly in the washing, and full strength to sharpen the edges of hedges and trees.

46

Summer landscape

Still the same view, fig. 29 was painted in oils with a palette of Flake White, Cadmium Yellow, Yellow Ochre, Alizarin Crimson, Light Red, Raw Umber, Viridian and Prussian Blue. Black was not used, but no significance attaches to this.

The distant hills were clear in the moist air, with lowering clouds above them. For most of the afternoon that the painting took, there was sun over the near fields, but the hills retained their cloud cover. These clouds were violet, edged with sulphur-yellow. The distant hills were deep violet-blue. The farther fields in shadow were a deep, saturated blue-green, trees and hedges varieties of deep green, blue and violet. The meadows in sunlight were bright golden-green, in shadow they were by comparison a dull, leaden green.

To give the impression of sunlight in a painting, every tone and colour in the shade must be related to the tone and colour you are employing in the sunlit parts. Tonal and colour variety within each area—sun or shade—has to be sacrificed. Detail as well may have to be suppressed.

The generally accepted rule that distance makes things appear pale and blue did not apply fully. Layers of air lend blueness to distance, but a warm light added red to this, giving the distance a purple tinge. Here was a problem. Cool colour—blue—makes objects look distant. So does a reduction in contrast between light and dark areas, i.e. less contrast between fields and hedges. But here, due to the clear air, there were nearly equally warm colours and only minimal loss of contrast in the distance.

Nevertheless there is a sense of distance. Linear perspective flattens the receding areas and pushes the boldest, roundest shapes towards the viewer (but this aspect does not concern us within the compass of this book). Paint texture is rougher and more varied in the foreground, and so comes forward. Here, contrast in hue is stronger too—purple blooms against dark green plants, violet flag-stones against yellow-green grass. (You must take these colours on trust, fig. 29 only shows tone.) The foreground forms are modelled solidly, three-dimensionally, with bulk and depth, compared with the flat, disembodied silhouettes of more distant objects.

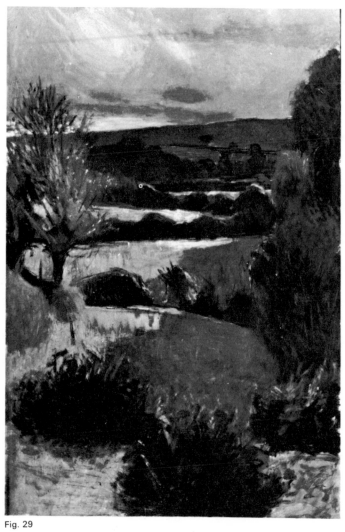

Fig. 29

48

If you employ considerable tonal contrast, as here, between sunlit areas and those in shadow, you cannot expect also to use brilliant colour. Strong tone and strong colour are mutually exclusive.

A lack of brilliant colour does not mean a lack of varied colour. The greens stretch from yellow-green to brown-green, from blue-green to grey-green and in tone from the palest yellow-green to blackish-green. This darkest green is mixed from Prussian Blue and Yellow Ochre. The strongest yellow-green consists of Cadmium Yellow and a little Viridian. White was used for the cooler, paler, less intense shades of green. These colours, regarded in isolation, are only faintly green. Against the violet paving stones and sky they become a positive green; an effect of simultaneous contrast.

Compared with orange and violet, green is the most flexible and elastic secondary colour. The unending harmonies which are possible within this one colour are a great fascination in landscape painting.

Odd problems arise in our attempts to paint sunlight. A white wall in shadow and a slate roof above in the sun can appear identical in hue and tone. But some part of the roof will be in shadow, perhaps only the edge of the tiles. This will be enough to explain their true relationship.

Reflected light from a brilliantly coloured surface in sunlight materially affects the colour of anything facing it, whether the chin of a girl in a bright blue dress or a white wall in shadow next to a red car in the sun.

A brilliant colour which is seen in both sun and shade presents problems—how to retain its brilliance, yet give it the tonal contrast which sun and shade demand. Yellow, orange and red do not take kindly to being lightened with white or to being used palely as washes. In any case they are sunny colours. Use them full strength for sunlit areas, darken and cool them for parts in shadow. Greens can be lightened with yellow or yellow and white in the sun. They can be given their full, saturated value in the shade. Blues and violets should be lightened with white only, or they lose their brightness and character. The warmer the colour, the more it will be itself in the sun; the cooler it is, the more will it retain its identity in the shade.

Under certain conditions, on a misty day, sunlight can suffuse and, so to speak, stain the atmosphere. Under a late afternoon sun distant hills can look positively yellow, under a luminous

pale yellow sky. As they advance towards the horizon, fields, trees, buildings will partake progressively of this warm haze.

This is an exception to the 'distance = blue, yellow = close-up' rule. But your painting can still present a feeling of depth and distance. The closer the objects, the truer will be their local colour, the greater will be the contrast in hue and tone between them— as already mentioned about fig. 29. So, even if their colour is cooler than the warm, distant haze, this will make them keep their relative position in space.

I am not the first to notice this. There are paintings by Turner and Monet of golden distances and cool but well-defined foregrounds.

Only in the hundred years since Turner have painters thought of sunlight and the effect it has on landscape as being a worthwhile subject. Artists before him were too preoccupied with problems of composition, linear perspective and the solidity of objects, to consider the accidental and fleeting effects of sun and atmosphere as worthy of study.

Snow-scape

Tree trunks, rocks, walls, even the sky appear dark by contrast with snow. One might think that snow-scapes would sort themselves into black and white patterns. They do to some extent, yet they are so obviously colourful.

Compared with snow, notice how a white wall, or in fig. 30, the white patches on the cows, look dirty yellow. Snow is a clean white and it is passive, sensitively reflecting whatever colours the conditions of the light impose. Sunlit snow can be pink, apricot, even yellow. In the shadows it looks turquoise, blue or violet. It reflects the moods of the sky, takes on whatever colour is imposed by distance; it never looks a blank white. It looks nearest white on a dull day. But then it may well appear darker than the sky and so again it cannot be fairly represented by pure white.

This watercolour was done on a bright morning with constantly changing light. I used Cadmium Yellow, Alizarin Crimson, Winsor Violet, Prussian Blue, Yellow Ochre and Raw Umber—only six colours in all.

There is no white paper showing anywhere. The lightest area of the painting is a pale orange, mixed from Alizarin Crimson and Cadmium Yellow, at bottom right, with a very delicate broken

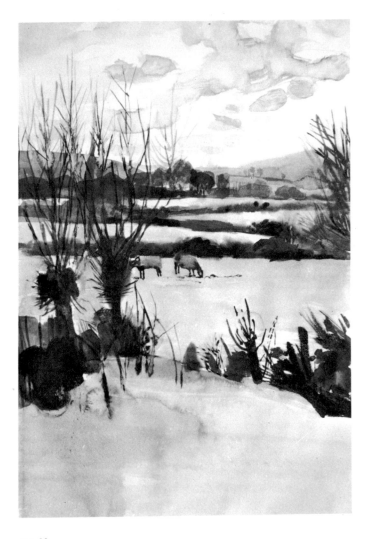

Fig. 30

wash of Prussian Blue over it. With watercolours the sequence of washes makes a very noticeable difference to the final effect. If I had put the orange wash over the blue, in spite of its paleness and transparency, it would clearly have been the dominating one. As it is, with the blue on top, it has a cool shimmer.

Most of the snow is painted in washes of Prussian Blue and Alizarin Crimson. There is a little Violet too, but this is toned down with yellow.

The dark reddish trees and hedges are broken up by small areas of dark grey-green, mixed from Prussian Blue and Raw Umber.

The yellow in the sky also pervades the far distance, neutralizing violets and blues—an example of the warm distances, mentioned on page 49–50.

Broadly, the painting falls into three parts: yellow sky, blue snow and red trees and hedges. Each one of these parts is enlivened by its complementary secondary colour—violet clouds in the sky, orange on the snow in the foreground, green patches in trees and hedges.

Night scene

Photographs of night scenes are not a good guide to what we really see. Long exposure times over-emphasize detail and exaggerate the size of lights. Yet night scenes can hardly be painted from nature. If there is enough light on your board to paint by, you won't be able to see the scene. Eyes cannot adjust rapidly enough from light to dark.

As with fig. 31, a combination of day-time sketch and diagrammatic notes at night are probably the best foundation for your painting. This painting was done in Conté crayon, coloured inks and white gouache for lights and lit windows.

Half-close your eyes in a well-lighted street and you will only see the actual sources of light: street lights, shop signs, traffic lights and the lights of cars and buses. The sides of buildings, road surfaces, even the outlines of buildings against the sky will disappear, proving how vastly brighter the lights are than the surfaces lit by them. Only reflections of the lights on shiny surfaces or the wet road will be comparably light.

Do not try to show too much detail and contrast within the dark areas. The simpler they are kept, the more effectively do they convey the feeling of darkness. The less light there is, the

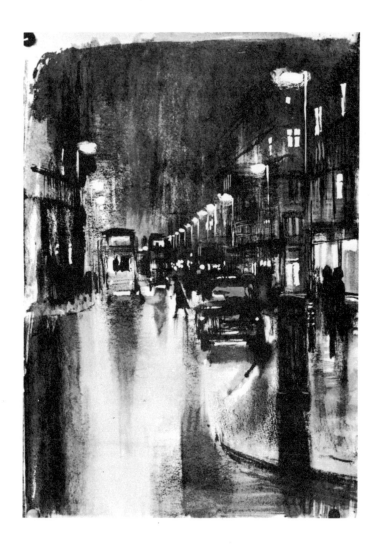

Fig. 31

more indistinct colour becomes. Tonal contrast only is apparent, so do not attempt to define the local colours of buildings, trees, roadway etc. Colour is more likely to be reflected from surfaces which face, and are near to, coloured lights.

Moonlight, however strong, drains nature of colour, making objects which we know to be rich in hue, leaden and washed-out looking. This is due to the limited spectrum of moonlight.

Street lights, car headlights, all sources of artificial light are cleanly brilliant in hue, crisp and sharply delineated. Do not overdo the halo of light around them, either in brilliance or in size. It will not give a greater feeling of light.

Lights are crisp and sharp; other detail, unless it is silhouetted against lights, will be indistinct, with little tonal variation and modelling. Objects appear as flat, tonal areas, rather than as solidly modelled forms. The farther away they are, the dimmer they look. Distant detail merges into the background even more than it does in daylight. (Think how near a friend has to be at night, before you recognise him in the street.)

Few artists have made a success of night pieces. The most famous of all, Rembrandt's *The Night Watch,* is not one at all, it is a day watch. In the 17th century Georges de La Tour painted figure groups, lit by single candles. They are very beautiful paintings, concerned, like Rembrandt, with the dramatic effect of concentrated light on selected surfaces.

Whistler turned night scenes into sophisticated decorations without giving a real feeling of darkness. Van Gogh painted *Café at Evening,* using yellow and orange for the lighted café and for the light-reflecting underside of the awning. Buildings in the background and the sky are painted in their dark complementaries, blue and violet, setting up a see-saw of contrast. Green and red in small areas provide an echoing clash. Van Gogh has gone against all the rules: using strong colour to indicate darkness; using yellow and violet as substitutes for light and dark; putting wide haloes around lamps and pale green stars; giving an effect of light and dark without the use of cast shadows. Being Van Gogh he gets away with this highly personal interpretation. By the intensity of his genius he persuades us of the truth of his painting.

Flowers

A bunch of flowers has depth. Roughly spherical, the bunch is a solid shape and this must be conveyed, probably by tone. Yet the colour of the individual flowers will usually be the real subject of your painting: So a conflict arises between colour and tone.

Fig. 32 reproduces a watercolour painting of a bunch of Korean chrysanthemums. These were the colours: green leaves and stalks, pink-violet petals, yellow flower centres. The green is the darkest, pink the lightest, yellow the most intense. The background is yellow-grey, the jug terracotta, the table top blue-white.

Light, falling from left and above, leaves the right and the underside of the bunch in shadow. The group of blooms at top left is in the strongest light. There is as much distance away from you from the front of the bunch towards the jug, as there is at left and right, where you see the bunch in profile. This sense of depth has been given by tonal means.

The pale lilac of the petals appears in its true, local colour on the left. When painting the same colour in light and shade, two obvious but equally misguided solutions should be avoided. One—simply deepening the local colour—turning pink into red, or pale violet into deep violet. The other—adding black to a colour, or, in a wash drawing, putting a wash of grey over (or under) the local colour. This is how primitive colour photos were done. A black and white print had flat washes of the approximate local colours superimposed. (But it must be admitted that this too is the way, even if somewhat more complicated, that the old masters used the technique of dead-colouring.)

The cooler the local colour (blues, violets), the nearer and truer to it will be its shadowed version. Shadows generally are cool in colour. Therefore these cool colours are not distorted as much in shadow as are warm colours. Try to see colour, rather than neutral tone, even in the deepest shadow.

The green leaves lose most by being in shadow, draining the green of yellow and leaving it dull. Oddly enough, considering what shadow does to green, the yellow flower centres retain much of their brilliance in the shadow. The yellow turns to a rich, insistent khaki-gold. Against theoretical expectations, yellow stays strong in shadow. This will often be difficult to render in paint. Only by sacrificing the character of other colours, making them exaggeratedly neutral, will you be able, by contrast, to give the richness of yellow.

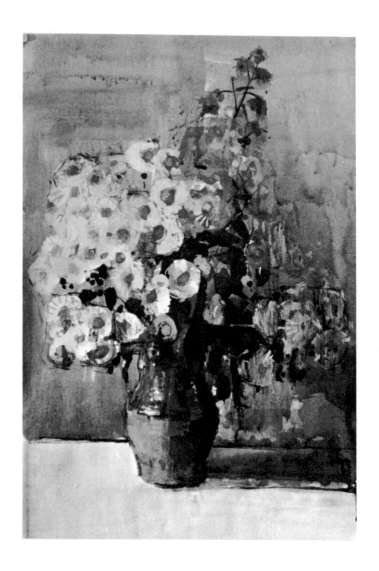

Fig. 32

56

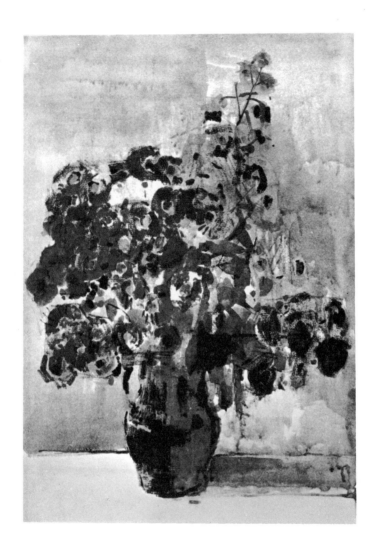

Fig. 33

A rough-textured creamy yellow blanket forms the background. Laterally glancing light darkens it, making its general tone darker than the flowerheads, which face the light squarely.

This brings me to an important point. Flowers are too often regarded in isolation. Their size, colour and character make one handle them and look at them closely, without regarding the environment. Botanical artists are right to do this, but if you want to paint a picture you will serve them better by including the background. Every colour within the rectangle of your painting has an influence on every other colour. Stark, staring white is not a good foil for colour, whether it is brilliant or subdued.

This painting was done on white paper with coloured inks, gouache and a very little wax crayon.

Yellow and Violet ink make the background; warm yellow-grey merging into light brown. The flowers in the shade are Violet and Sepia ink with a little Prussian Blue to cool it in places. The green, a very dull colour in the shadow, consists of Prussian Blue and Sepia. A wash of Yellow is overlaid to give some richness.

Photographed, with a strong light behind the painting, fig. 33 allows you to see the relative paint thicknesses, showing in the darker tones where gouache was used and where ink only. You will notice that the paint is thickest in the lightest parts, the flower heads at top left. It is easier to give an impression of solidity, of coming forward, by using opaque paint. The positive textures of freely applied opaque pigment with its rough edge and indication of direction in the brush strokes imply more successfully advancing solidity than the negative shapes of carefully left-out white paper.

Alizarin Crimson, Winsor Violet and white gouache are used for the flowers in the light. If the same hue had been mixed as a wash, letting the white paper provide the white, probably only violet would have been used. But as soon as white paint is added, crimson must be added too, to counteract the cooling influence of white.

Dark green and blue wax crayon were used in the drawing of the leaves and to make the outlines of the jug firmer. A unifying texture was given to flowers in the shadow by lightly dragging green crayon across them.

Reflection and transparency

Trickily realistic paintings of brass, glass, copper, silver, porcelain and dew drops on rose petals seem to me a waste of time and ingenuity. They completely misunderstand what painting is about. Concerned only with surface qualities, literally superficial, they are no more than an impersonal display of dexterity.

This kind of painting has always been admired by the wealthy and somewhat naive, from the 17th-century Dutch merchants, who commissioned opulent and ostentatious still lifes of exotic fruit, fish, fowl, gold and glass, to their 19th-century descendants in Boston and Birmingham, who thought the same paintings to have been the highest manifestations of human achievement—and paid for them accordingly.

Very often, the subject of the painting—the glass or precious metal—is in itself a work of art and the best the painter can hope to do is to provide a two-dimensional copy, without adding anything personal.

But there have also been some very beautiful pictures painted of reflecting and transparent objects; by Vermeer in the 17th century, Chardin in the 18th, Manet and other Impressionists in the 19th, Bonnard and Vuillard in this century. Concern with the quality of paint, rather than the degree of illusion, distinguishes theirs from the other, rather awful kind.

Fig. 34 was painted in oils. There is a glass wine jar and beer mug, a brass candlestick, an aluminium coffee pot and the inevitable copper kettle.

Glass and shiny metal have this in common; that the colours and tones surrounding them are more important than their own colour. But however shiny or transparent, metals and glass do have colours of their own. These colours will be apparent, however much they are distorted by what they reflect or transmit. In the candlestick the warmest colour, a rich yellow, is still cooler than the coolest colour in the kettle. This is a pink-grey where the coffee pot is reflected in the copper. High-lights are an exception. They will in every case, whatever the colour of the object, probably have to be pure white. Be sparing with them. Add them last and only where absolutely necessary.

The aluminium is reflected in the copper, but there is an interchange of reflections, where they are next to each other: pink on the aluminium, grey on the copper.

Fig. 34

The most complex effects are on the glass. You can see its own colour, particularly along the edges (if glass were completely transparent you couldn't see it at all). Colours behind it are seen through it. It reflects other objects and there are brilliant high-lights on it. So there are four qualities, sometimes several superimposed on each other. But however complicated the effects, they are rational; there are explanations for them. The shape and colour of a reflection is determined both by the curvature of the reflecting surface and by the size, shape and colour of the reflected object. The position and strength of high-lights is directly related to the position and strength of the source of light. Understand what you see and you will be a long way towards a successful interpretation of it in paint.

A bewildering mass of reflections can often be simplified into two or three colours and a manageable number of shapes. In this painting, the candlestick is the most complicated shape, but it is described satisfactorily in only four colours: a deep khaki made from Yellow Ochre and Ivory Black; a lighter one, nearly pure Yellow Ochre; two light colours for reflections, a pale Lemon Yellow and a rich Cadmium Yellow. Apart from these four a few marks in Viridian are used to indicate structure and there are two spots of pure white for the brightest high-lights.

On the copper there is a range of warm hues, fairly close in tone to each other—orange, Cadmium Red, Light Red for reflections and a series of cool pinks, purple, grey-violet for parts where the colour of the copper itself is more apparent.

Four greys on the coffee pot, apart from the copper reflecting pink-grey: a light one, made from Ivory Black and Flake White; a medium one, mixed from Raw Umber, Viridian and Flake White; and two dark greys, similar in tone, but one warm in hue, based on Raw Umber, and a cool one, containing Prussian Blue and Viridian.

To allow the colours of the brass, aluminium and copper to be as telling as possible, I chose a neutral background—grey, buff and deep brown.

Colour notes

It is little use writing 'blue' on the sky, 'green' against trees and 'red' on roofs of a black and white drawing. You know that anyway. It is not worth spoiling the look of your drawing for that.

Colour notes, to be useful, must be precise and informative. They should recapture the feeling you were given by the colours at the time of drawing. When you come to use the sketch for a painting, it must enable you to recapture this feeling, weeks, months or even years later.

Key words can remind you not only of reasonably exact colours; relative tones can also be indicated. How dark, for example, a white wall looks against the sky. In the drawing, fig. 35, I remind myself of the appearance of dull red paint-work against rust. Textures can also be described—'brick', 'stone', 'rough', 'smooth'.

Subtle hues need noting more than brilliant colours and contrasts. The colours in my drawing are all pretty dim: Ochre, steel-grey, dull green, pink-grey, chalky white, red rust, dense Light Red. Even though they are dull colours, they vividly remind me—more than the drawing does—of the scene I saw five years ago.

To anyone else, one's colour notes may be quite meaningless (mine probably are to you). But that is their point, they are personal reminders.

When out for a walk, or indeed at any time—now will do—look at an object and describe to yourself all its hues and tones. Realise them as sharply as you can and describe them as minutely and precisely as possible. Try to find words for the finest nuances in shade.

61

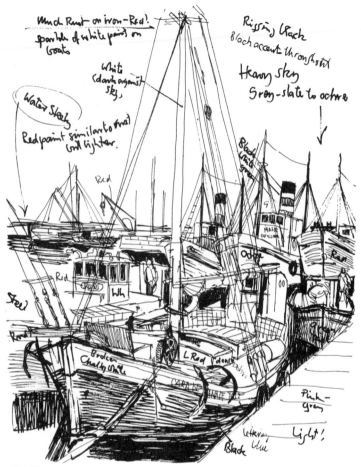

Fig. 35 .

One can't paint a picture in one's head, but this will help you
to see colour more analytically; and before you can mix any colour
you must be aware of its existence.

5 The scope of colour

The last chapter was about colour and tone seen in nature and the means available to us for representing them. We examined nature and tried to find colours on our palette to echo what we saw.

Physically, unless we are colour-blind, we all see the same things in the same way and in the identical colours. The human eye may be similar to a photographic camera, but our brains are not dark-rooms. What we make up there of visual impressions is personal and has only subjective meaning. To express it and convey the meaning to others we need a vocabulary.

But words in a vocabulary are composed of individual letters, the alphabet. The following exercises are meant to help in developing this alphabet on which to base our individual reactions to the visual world.

Yellow still life

Yellow is the palest of the primaries, soon losing its identity when an attempt is made to darken it beyond its limited capacity. In spite of this it has quite a range, from pale lime, through lemon, chrome, yellow ochre to near orange. Cream and near-pink, grey, olive green and khaki fringe it.

The still life, fig. 36, explores yellow. Painted in oils, the following palette was used:

Lemon Yellow, Cadmium Yellow, Yellow Ochre, Winsor Orange, Cadmium Red, Burnt Sienna, Raw Umber, Viridian and Flake White.

The composition is deliberately simple. The basic shapes of the component parts—the fruits—allow colour to be the most important element. I tried to see every part as colour, disregarding tone, shading, solidity and perspective.

The background was a dull creamy-yellow cloth. The apples, lemons and bananas were yellow, but the oranges, strictly speaking, were not. The oranges, shaded areas on the apples and the shadow on the cloth had to be persuaded to come within the orbit of yellow. Conceivably, if I had painted a red or a green picture, some of these colours could have occured, but there they would look yellow—another example of simultaneous contrast.

Fig. 36

An interesting and important point emerged as the painting proceeded. The widest range of colours recognisable as yellow was possible in the middle register, half way between the lightest and the darkest tones. Here, in this middle tone, are the most varied colours in all directions—towards green, towards red (or orange), and towards grey—which one can recognise as yellow.

The lighter tones soon become cream, pink, grey or green. Equally in the darker regions brown, red, grey or green were lurking, limiting the scope.

Each primary and secondary colour has its most comfortable tone. Where it is most intense and purest it is also most elastic and has the widest range of hues.

I have seen many examples of a certain kind of painting, done in one colour. In an attempt to be dramatic these pictures are usually painted in Violet, Prussian Blue or Viridian. Often they are of intensely emotional subjects—religious, political or doom-laden dream-like episodes.

There is nothing inherently wrong with paintings done in monochrome. But the artist ought not to expect his single colour to play any important part in giving feeling to his work. One hue

alone, whichever one it is, will always be neutral. A further point which makes it difficult for these paintings to be successful is this: brilliant colours, even the darkest, are no substitute for tone. The strongest, most intense colour (in these paintings used for deep shadow and modelling) will always tend to advance and come into the foreground. It is best to stick to black if you want to work in monochrome.

To explore the possible range in hue and intensity, as well as tone—like this yellow still life—is a very different thing.

Other subjects through which to explore single colours are bunches of leaves, groups of vegetables (green), a bowl of cherries and tomatoes (red), a loaf of bread on a board, an old pair of boots (brown), china and glass (white and grey are colours too). The whole of these paintings, including the background, should be within the range of the same colour.

Hands

The sky is blue, leaves are green, tree trunks brown, lips are red and flesh is pink—but luckily not. If they were, painting would be very uninteresting. The ancient Egyptians used stereotyped colour—all women were painted white, all men red—and produced some of the dullest art of all times.

Look at your hand; there is no flesh-colour.

Quite apart from light and shade, how varied the colours are. The finger-tips are pink and the knuckles too are pink, with a tinge of purple. Veins add a delicate blue, violet or even green. Yellow, grey and mother-of-pearl sheen are there. If you are sunburnt the back of the hand will be warm colours, gold, orange, brown. By contrast the palm and inside the wrist are pale and cool.

Bunch one hand into a tight fist and compare it with the other. The taut skin on the fist has different colours from the loose and textured skin on the other hand. Hold one hand above your head for a few seconds. Compare it with the other and it will look pale and waxen. There are infinite variations of colour, depending on age, race and build, state of health and occupation. There is no flesh-colour.

Ignoring exact proportion and detail, draw a diagram (fig. 37) of your hand, not smaller than life size.

You will need a fairly full palette, whether oils, gouache or watercolours (I used gouache). For instance: white, Cadmium

Fig. 37

Yellow, Yellow Ochre, Alizarin Crimson, Burnt Sienna, Burnt Umber and Viridian. You may wish to add Cadmium Red, Prussian Blue, Raw Umber and black.

Look at your hand in as flat a light as possible, the light falling over your shoulder, so that there is as little tonal modelling as can be.

Try and match every colour in relationship to its neighbouring colours. Hold samples of the actual colours against your hand to make sure of exactitude. Also compare closely related colours, for instance pink of finger-tip with pink of knuckle.

Mix each colour from as few components as possible. The duller, the more neutral the colour you wish to mix, the wider the choice of constituents. A neutral grey, for instance, can be mixed from any number of colours. Of course, you can also mix it from black and white, just two colours. When you cannot decide and shove in a bit of this and a bit of that, pause, think, and start again.

Do not rely too much on white or the colours will be insipid and indecisive. Make colours as positive as possible, to the point of exaggerating their differences.

Mix each colour separately. Don't use an all-purpose colour, adding bits of yellow, red or blue for individual touches.

Neatness is not important, but do not let too much of the background colour show between the individual colour patches.

Fig. 38

It would affect the truth of the balance. Keep each colour-patch defined. Do not merge or shade individual marks into each other.

When you have done this chart of your hand, strictly analysing local colour, try the same thing with your hand in cross-light, so that the back of it has the light glancing across it. Colour-match the parts in shadow as well as those in the light.

You will find it difficult to decide what colours you really see in the shadows. The first impression may be of a neutral tone, a warm grey. Then you find that it is much cooler than the parts of the hand in full light—so it is greenish. But on second—or third—thoughts, there is after all a lot of red in it, so back to warm grey. Only by constant comparison can one arrive at a decision. It is not the truth of one spot of colour, but the relationship of many, that reveals the truth.

The same exercise in objective colour-matching can be done with a flower or a cabbage-leaf, an apple can be used, so can a single autumn leaf or your face. If you do a chart of your face, forget all about likeness, solidity, drawing or expression. Confine it to skin areas only, ignore eyes, eyebrows and hair. The aim of this exercise is to find the variety existing within closely related colour. To introduce areas of widely varied local colour would defeat this end.

Fig. 39
Collage copy

This is another exercise in strict analytical colour-matching. Paste pieces of torn coloured paper on a plain background— black for preference. Over-lay this with scraps of tissue-paper in several layers. Instead of coloured paper and white tissue-paper you could use coloured tissue on a white ground. Don't make it too complicated or large. The original of fig. 39 is about 6 x 8 in. The actual colours and pattern are of no great importance, but don't use colours that are too brilliant, and make sure it is a design that pleases you. Better work is done if it involves something that pleases and satisfies you.

Now for the point of the exercise. Copy the collage as carefully as you can. Make your copy, fig. 40, the same size as the original to enable you to make strict comparisons.

If you use a wash technique (as I did), try to match each colour in one go, rather than adding wash after wash till you are there. The more neutral colours, as well as brilliant ones, look better for being got in one.

There is an exception to this rule: superimposed washes of contrasting colours. For instance, floating a red wash over a blue one will result in a more lively violet than if it is done in one

Fig. 40

wash, from red and blue mixed on a palette. Lively neutral hues result from washes of two complementary colours, say orange and blue.

Painting a landscape, a still life or a figure subject, one cannot put subject and painting side by side for exact comparison. Scale, perspective, high-lights, reflections, deep shadows, and above all the qualities of three-dimensional depth make it impossible. But in this exercise you can lay one against the other and make certain of verisimilitude.

Verisimilitude is not a quality that has much to do with art, but it is an excellent test of an artist's control over his medium.

I chose self-portraits as the subject for the next four paintings (figs 41, 42, 43, 46 and 20) simply because the model is always at hand, ready to pose for as long as one feels like painting and not offended if one fails to do justice to youth and good looks. Here again, we are not concerned with likeness and the finer points of drawing. These exercises are not meant to show you how to paint pictures, only to help with one aspect—colour. Yet you may find that a more relaxed attitude to drawing and composition will in fact produce interesting results—an un-looked-for bonus.

Pointillist self-portrait

Putting touches of pure colour next to each other and letting the eye do the mixing may seem to be the most scientific way of dealing with colour. But are the colours pure primaries? Is the white of paper (or board or canvas) an optically sound background?

Rules and theories are reassuring. They bring order to chaos. But the theory behind Pointillism only proves the eyes' ability to 'mix' colour. All colour reproduction is based on this. Look at a colour plate in this book through a magnifying glass and you will find it composed of red, blue, yellow and black dots of varying sizes, regularly disposed. (The black printing is added only to give strength to deeper tones. Some cheap colour reproductions manage with just the three primaries.)

As long as we don't kid ourselves that we have produced a scientific work of art (a contradiction in terms) we can benefit in other ways from this exercise. It helps us to look at colour analytically. Secondly, and this may be of greater use to you as an artist, it produces interesting textures. Being incidental, they are free of self-conscious, contrived qualities.

My drawing, figs 20 and 41, was done with oil pastels, most of it with Magenta Red, Turquoise Blue and Lemon Yellow (the three colours used by colour printers as primaries) with a little violet, orange and green. It could, of course be done in any other technique: oils, gouache, acrylic, watercolours or ink. I have let the white paper play a part. If you use oils or other opaque paints the primaries can be mixed with white to give the lighter tones. The individual touches of colour can then be put side by side without ground showing through. This is how Seurat, the inventor of Pointillism, used it.

The insoluble paradox, which invalidates all claims that Pointillism is scientific, is this. White *light* consists of all the colours of the spectrum. A mixture of *pigments* of all the spectrum colours produces a dark grey. So, in painting, white can never be mixed from colours, and must be accepted as a colour in its own right, either as a pigment or as the ground.

Theoretically, one can produce the full range of visible colours by Pointillist mixing of the primaries. I found in my attempts a tendency to get thin, non-descript, slightly acid colours. In fact, even Seurat had to use colours apart from primaries and secondaries.

Fig. 41

Limited palette 1

The next two paintings were done with palettes of only four colours, to explore the scope of these colours, to learn something about colour harmony, but mainly to find out about the representation of flesh.

They were painted in oils. If you try it in watercolours, only three colours will be needed—the white is supplied by the paper.

For fig. 42 (see also fig. 20) Yellow Ochre, Light Red, Ivory Black and Flake White were my palette—dull, warm colours. None of these are primary or even secondary colours.

Yellow Ochre and Light Red, when compared with Cadmium Yellow and Cadmium Red, are already well on the way to a neutral grey. Yet they present unlimited possibilities. Their very limitations sharpen one's senses and one discovers colours one was not aware of before.

Neither blue nor green being available, the coolest colour is a grey mixed from black and white. Yellow Ochre and black make a dull green. So there is a range from black through greys to white, with Yellow Ochre added in various proportions. For instance, Yellow Ochre added to a light grey makes a warm, creamy colour. Equal quantities of white, black and Yellow Ochre also make a warmer colour than any two of the components by themselves.

With white, black and Light Red you get similar variations. White, with only a little Light Red, makes a sharpish pink. This colour is used on the nose, the cheek-bone and the neck under the ear. A very light tone of it is also used in the background. (Except for a high-light on the spectacle lens there is no pure white in the whole painting.)

The addition of white completely changes the character of any colour—remember the exercise, fig. 8. It makes colours cool, dusty and opaque. Too much white will make a painting look chalky. Ask yourself whether white is really necessary in the colour you are mixing. Also question your use of black; a painting can be sooty. Even a combination of the two is possible—half chalky, half sooty, through too generous addition of white for light and black for shadows.

Whatever a colour may represent, whether a high-light or the deepest shadow, try to think of it as a colour in its own right, and whether it looks good in the company it keeps.

Black is used extensively in this painting, but as a positive

Fig. 42

colour. Shirt, hair, spectacles are black with hardly any modulation by other colours. Black is a colour and can be very beautiful and telling.

Black as a neighbour will act on other colours, making them richer and more glowing. Think of the lead cames in a stained glass window.

Yellow Ochre and Light Red are tertiary colours. Theoretically any tertiary colour (a colour containing elements of all three primaries) can be mixed in three ways. One way would be to mix, say, Yellow Ochre from yellow and black and Light Red from red-orange and black.

Another way is to mix tertiary colours from primaries. Not only Light Red and Yellow Ochre, but also Raw Sienna, Burnt Sienna, Raw Umber, Burnt Umber and Naples Yellow can be very closely approximated from Cadmium Yellow, Cadmium Red and Cobalt or Prussian Blue plus small amounts of white.

A third way of mixing them would be to add elements of the complementary colour to a primary or secondary. For example, to add a little blue to a reddish orange to make Light Red.

So we have three ways of arriving at tertiary colours:

By adding black to primaries or secondaries.

By mixing them from elements of the three primaries.

By mixing two complementaries in various proportions.

In these ways something very close to the original colours can be achieved, but there are qualities in pigments apart from hue, such as intensity, transparency and density. The Siennas and the Umbers, for instance, are transparent and cannot be exactly duplicated if mixed from opaque primaries.

Fig. 43

Limited palette 2

In contrast to the last painting, fig. 43 (see also fig. 20) was painted with cold colours, but again using only four: Lemon Yellow, Alizarin Crimson, Ultramarine and Flake White.

One possibility with Light Red and Yellow Ochre was to see how bright an effect it is possible to get with these muted, warm colours. Now there may be a challenge to achieve as rich and warm an impression as possible with these cool, raw colours.

The warmest colour is a mixture between Lemon Yellow and Alizarin Crimson—a pale orange. Adding more yellow and a little Ultramarine gives us a light, dusty brown. A little more red and we get an edgy maroon, or, with more blue, a neutral grey. Lemon Yellow and Ultramarine make a range of greens from pale lime to a greyish medium green. To arrive at these colours, Alizarin Crimson and Ultramarine have to give up their character, which they hate doing and do ungraciously. And Lemon Yellow is too pale and unassertive to counteract the purple-blue bias.

So, rather than forcing the colours, it may be wiser to swim with the stream, to find what possibilities there are within their natural climate.

Using this palette you may come to different conclusions, but I found Ultramarine taking charge. The fact that it is the darkest of the three colours may be partly to blame for this. But I did try not to use it merely as substitute for black.

With the blues, violets and purples in charge, other colours are used to flatter and appease, not to oppose them. Even in the flesh there are greys and a pale blue-green, cold pinks and pale blue, a pale violet. White plays an important part in these colours. Although not used in full strength by itself, it is here a colour in its own right, chiming with the cool hues.

Fig. 44

Fig. 45

Heightened colour

If in a painting you change a pink dress to red, and a buff wall to yellow, you do not heighten colour. The dress *could* be red, the wall *could* be yellow. To heighten colour one must keep the dress looking pink, the wall buff, but pink and buff that have never been seen before; of a luminosity and strength that asserts them as positive colours. Complementary contrast and simultaneous contrast will play as important a part as the intensity of individual colours.

In this painting, fig. 46 (see also fig. 20), I have taken the colours which make up the head and pushed them as far as possible. The green background helps, as most of the colours look warm against it.

Yellow, orange, red, brown and pink of the skin are warm and weighty by contrast. A bright Cadmium Red—the complementary colour to the green of the background—forms the counter-point. There is hardly any white used, except in the green of the background and the small touches of hard pink on the face. White (or black) is never used for tonal modelling. Colour, not tone, is the aim. But do not use the relative tones of colours as tone-equivalents: yellow for the lightest tones, violet for the darkest, orange, red and green for the intermediate tones.

There is a sense of depth in this painting because green and blue—the retreating colours—are used around the edges of the head; the edges being the part farthest from us. Not only are green and blue the optically retreating colours, but the green background also merges with the green used on the edges of the head, helping them to recede further.

The basic scheme is founded on red-green contrast; orange-blue contrast forms a secondary pattern running through it.

Colours are put on as separate flat areas. Some are less than $\frac{1}{4}$ in. in any one direction, others (on forehead and hair, shirt and coat) stretch for several inches without modulation. Colour does not constantly have to vary. Perfectly flat areas of colour, as long as they are the right colour, can be most effective.

Many of the smaller areas of colour are intensified by simultaneous contrast. A dull green spot on the neck, surrounded by red and red-brown, looks far stronger and brighter than it would if placed against a neutral background. A blue patch under the lower lip, surrounded by orange and red, gains in brilliance for the same reason.

Fig. 46

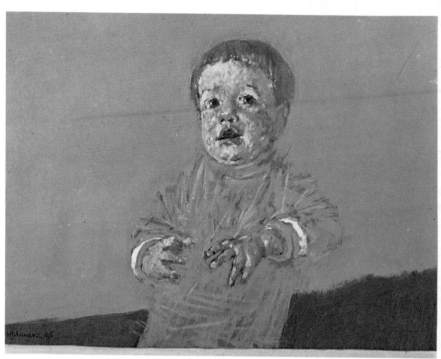

Fig. 47 (detail)

Fig. 48

The relative size of colour-areas affects how we see them. A small red dot on a green field will be intensified. Reverse it, put a green dot on a red field and the green will be made more positive. Here the effect happens twice: the head is a red dot (if a large one) surrounded by green. And within the head itself the cool colours, green and blue, are dots surrounded by red.

Brilliant complementary hues of similar tone, when placed next to each other, jostle with a flickering edge between them. This is an uncomfortable sensation, but it can be useful, as it is to Op-painters, who use it to give an impression of movement and insecure balance. In my painting it helps to tilt some surfaces, for instance the red and green in the complicated changes of planes around nostrils and upper lip.

Colour replaces tone in this painting. The stronger the colour, the less tonal modelling is possible. The colour pattern is more important than modelling by light and shade.

My palette consisted of Cadmium Yellow, Yellow Ochre, Winsor Orange, Cadmium Red, Alizarin Crimson, Light Red, Winsor Violet, Ultramarine, Prussian Blue and Flake White.

None of the last four paintings come near to being an objective rendering of what I saw in the mirror. But the distortion and stylisations were determined by the task and the actual pigments, rather than by personal taste and feeling.

6 Towards a personal sense of colour

Discovering the potentialities of your palette and analysing the colours of objects are only the alphabet of the language of art. The personal and evocative qualities which colour possesses must come into play for a work of art to materialise.

Green with envy, in a blue mood, seeing red, black despair— colours are not just sensations on the retina, they are feeling and emotion. The days of the week have colours. Thursday for me is brown, Monday green (not blue), Friday violet. Many of us identify numbers with colours. I think of 3 as yellow, 5 as blue, but they add up to a reddish-brown 8, not a green.

We have favourites. Yellow, orange, grey and brown are my friends. Just thinking of them makes me want to paint.

This personal range will be enhanced and enriched by experiments with other colours. You will use your natural colours with more conviction, and have more confidence, by having learned about other colours.

Deliberately paint pictures with colours unnatural to you. If white paint is a constant adjunct, try and do without it for a while. If you have always felt most at home with muted colours, use brilliant ones.

You may find that you have been slipping into set habits, that timidity and ignorance, and not taste, conviction and personality have limited your palette and your scope.

It is impossible to speak about colour and completely ignore composition, drawing and design. For instance, Rembrandt and Braque used similar colours—Rembrandt to give a sense of light and depth, Braque for flat, decorative effects. Black in a Rembrandt is used in shadow and mysterious distance, quite different from the heavy black outlines and flat areas in a highly stylised Braque still life.

If you were to extract the actual colours of a masterpiece in the form of colour squares or a colour chart and compare them with the equally charted colours of a chocolate box top, I doubt whether you could guess which colours constituted the masterpiece. Gradations, juxtapositions, and the shape that individual colours take, matter as much as the colours themselves.

Fig. 49

Crumpled paper into pattern

New elements enter at this point—creative choice of colour, designing and pattern-making. These elements are present whenever you pick up a brush or pencil, but so far they have been a by-product, ignored and even discouraged.

Fig. 50 is a painting done from a crumpled piece of brown wrapping paper. A bit of crushed paper is an accidental and arbitrary object. We need not feel that we do injury or injustice to nature if we alter it in the painting, distorting drawing and colour. Fig. 49 is a photograph of the one I worked from.

The subject suggested colours and shapes. I used these colours and shapes to make an interesting design, rather than to make it look like the bit of paper. The colours I used are based only tenuously on the actual colours of the paper: pink, yellow, a warm brown, grey, violet and a dull dark green.

Fig. 50

Creative colour need not be brilliant colour. There seems to be an unwritten law that the more briiliant and strident the colour, the thicker the paint, the greater the art. But I can think of many great paintings (ancient and modern) in subdued colour and thin paint.

The shapes made by tone in the piece of paper suggested the pattern. I selected irregular, straight-sided shapes for fig. 50. Triangles, polygons, any sort of shape could be the basis. They could be geometrically regular—squares, as in fig. 51, or equi-lateral triangles, they could even be curved, flame-like shapes. The fact that the result will look very unlike the object you began with is of no importance.

Any technique would be suitable. I used gouache. Watercolour or ink, the wash techniques, would be the most difficult because corrections are difficult. They don't let you change your mind and alter shapes or colours.

Fig. 51

Versions of this exercise could be done using striped or patterned papers, a piece of wall-paper, a page from a magazine or part of a poster.

Patterns and colour arrangements can be based on any subject, not only bits of paper. Still lifes, landscapes or figures could be used. Less obvious starting points would probably lead to more interesting results: a group of pebbles, wrapped chocolates in a box, a piece of drift-wood or a machine part.

You could base the design entirely on imagination. Shapes and colours can be found for abstract concepts like anger, sadness, speed or happiness. The four seasons could be interpreted, but without recourse to the obvious imagery of flowers for spring, the sun for summer, fruit in autumn and snow flakes for winter.

Applying a colour scheme

Divide a square into five parts, some large, some small. In fig. 52 there are two divisions of one third of the square each, one of one sixth and two of one twelfth each. The proportions can be different and there could be more or less than five divisions.

Using whatever medium you like best (the student who did this one used poster paint), paint each segment in a different colour. Chose the colour scheme carefully—one that pleases you. Allow in your choice of colours for the effect of the relative proportions of the segment.

Here, one third is butter-yellow, one third orange, one sixth black, one twelfth deep green and one twelfth violet.

In a sequence of squares, the same size as the first one, design a variety of patterns.

Now comes the difficult bit. Use the colours of the first square, the same colour scheme, in exactly the same ratio each time. In the example reproduced here, one third of each pattern is yellow, one third orange, one sixth black, one twelfth green, one twelfth violet.

It is not easy to judge the correct proportion of each colour. Mix generous amounts, you will probably have to re-paint some of the areas in a different colour to adjust the ratio.

Depending on which colours are adjacent, on whether the design is round and sweeping, jagged or linear, on how big the individual colour areas are, the common colour scheme will make an entirely different impression in each square.

It will be useful to repeat this exercise with other colour schemes, using the same, or different, patterns. The patterns used here are abstract, with the exception of the top left square which has a design based on flower-heads. I think it is a good idea to stick to abstract patterns. They allow you to see colours and shapes as themselves, rather than as symbols for animals, sky, buildings or whatever they may represent.

Fig. 52

Salisbury Cathedral

Unlike most other paintings illustrated in this book, figs 44 and 45 (p. 77), were not done specifically for it. Nevertheless they serve admirably to illustrate a point.

They are of Salisbury Cathedral and were done on the spot on the same day in late September. The weather conditions were similar for both. Fig. 44 was painted in the morning after rain, and fig. 45 in the afternoon with rain threatening and actually falling as I finished.

They are in a mixed technique of coloured inks, using pen and brush, and some gouache and crayon.

I can see now how far from the actual, literal colours I must have been. At the time, if not photographically true, they seemed true to the subject. Any distortion of colour was not done capriciously or to startle, but was inherent in the subject and in what I saw.

The reason for including them here is that the paintings are done in analogous harmonies. There is analogous harmony if the main colours of a painting have one colour, usually a primary or secondary, as a common denominator.

In fig. 44 this common factor is blue. Blue is the central, pivotal colour. I began the painting by drawing the main lines with blue ink in a broad nib. This set the key. In one direction, with blue as the starting point, the colour moves towards emerald green and nearly reaches yellow. In the other direction it gradates from blue to violet and brown-purple. This meets a yellow-brown which reaches out from the yellow. So a complete circle is formed: blue, blue-green, green, green-yellow, yellow-brown, brown-purple, violet, blue-violet and back to blue. The colours which contain the least blue are the least brilliant, most neutral. Blue is the most dominant colour in hue.

The second painting, fig. 45, is centred on a dusty purple. From there the colours move through brown, orange, yellow ochre into green-grey and return to the dusty purple key colour via grey, blue-grey and violet.

In this painting the key colour is muted, compared to the intense blue of the other; and not only the key colour but all the colours here are more subdued. There is, in fact, not a single touch of a pure primary. Nevertheless, the effect is no less colourful. Partly because warm colours, even when they are neutralised, have more glow than cold ones, but also because the largest single

area, the sky, is a brighter colour than the green-brown of the sky in the other painting.

Paint a piece of paper half blue, half grey. Hold it up with the top half blue and the bottom grey; a blue sky over a grey landscape. This will look brighter and more cheerful than when you reverse it—grey top, bottom blue—and think of it as a blue sea under a grey sky. We can't see colour in an entirely detached and purely aesthetic way. Through being a cool or a warm colour it will always suggest a certain temperature. It will never stay passively in the picture plane—colour will either advance or retreat. The shapes of any painting will always carry associations in your conscious and subconscious mind.

Back to Salisbury Cathedral. In this second painting, because the relative tones of various areas are close to each other, there is a flickering effect, which adds to the apparent brilliance: in the green-grey gouache over pink-brown ink in the wall at bottom right and in the light violet opaque texture of crayon over green-ochre in the foreground.

The technique of these paintings encourages and stresses texture, so there are few areas of flat, even colour.

I did not set out to do these paintings in analogous harmony. While I did them the phrase probably never crossed my mind. It was done intuitively. Only later did I become aware of the fact that it was analogous harmony which gave their colour its character.

Beach tent

As I mentioned before, the most disturbing colour effect occurs when two intense complementary colours of exactly the same tone come next to each other. The only two which qualify fully are intense hues of red and green. No other pair has the identical tone at full intensity. It will work to some extent with orange and turquoise blue. And some colours, which are not complementary pairs, have a similar, if not quite so startling, effect: orange and green, red and blue, orange and magenta.

Only with red and green do you get to the full the floating, shifting feeling. First one, then the other colour will swim forward, a shifting dark edge between them. So strong is this sensation of a ridge between the two colours, that one actually has to touch the surface to make sure that it is not in fact in relief.

The drawing (fig. 53) of a beach tent was done on a blustery day. The stripes on the flapping canvas were in fact green and white. There was a blue pelmet and an orange roof to the tent.

In the painting (fig. 48, p. 80), I tried to give the shivering, shifting feeling of the moving canvas by changing the colours, using this red-green phenomenon. The blue of the sky, which is the same tone, invades the green stripes, adding further movement and a feeling of insubstantiality to the painting.

The obvious way to impart a sense of drama to a painting is to use widely contrasted colours; not only in hue, but also in tone. Dark against light makes an impact. But, as tone and colour are mutually exclusive, the colour will not contribute much to the drama.

Fig. 53

90

A subtler way, then, is to go to the other extreme. Closely matched tones of different colours give a sense of tension and unease. The stronger the hues, the more successful this will be.

Theoretically, it would be possible to paint a picture with the tones of all the colours so carefully balanced that a black and white photograph of it would show only an even, flat grey.

It can be taken a step further. By reversing the colour roles, by darkening the usually light colour and lightening the dark one, one gets unexpected harmonies (and dissonances). For instance, try placing a deep, saturated yellow next to a pale violet. Bonnard was very fond of this device and used it to give sophisticated elegance to his common-place subjects.

Persistence of vision is another effect associated with brilliant colour. Look for some seconds at a patch of bright colour. Then look at an area of neutral grey or close your eyes. The same shape, but in the complementary colour to the one you have been looking at, will swim before your eyes.

This may seem on a par with the optical illusions reproduced with monotonous regularity in the children's pages of women's magazines. These phenomena in themselves have no very profound significance, but an awareness of them has greatly influenced the development of modern art.

7 How colour has been used in painting

A warning

Vast numbers of art books are produced, many of them with colour plates. These plates often look extremely attractive, but they are deceptive. Unless they reproduce miniatures or only a tiny detail, they inevitably show the painting in a greatly reduced size. And not only is there loss of detail, but there is also distortion of emphasis. A red patch, the size of an apple in the original, shrunk to the size of a pin-head, will not have the same impact or convey the same meaning, even though everything else is also brought down to the same scale.

Reproductions will often look far prettier and more approachable than the original. Faced with the original for the first time, you may be disappointed by its toughness and the hardness of its colour. Not only the distortions due to reduction in size, but also the softening and harmonising effects of colour reproduction are responsible.

Colour reproduction—whether half-tone, litho or photogravure—is usually printed from four plates: red, yellow, blue and black. Tiny dots of each colour, varying in size according to how strong the colour is in any given area, combine to give an illusion of a full range of colour and tone. Now, there are several characteristics of these processes which give false softness and harmony to a print.

There can be no sharp edge to any colour, since the edges are broken into dots. Edges are also blurred because it is nearly impossible to print the colours exactly above each other—to register them, as it is called.

Even if the plates are made with the dots exactly the right size to carry the relative amount of ink, when it comes to the printing the thicknesses of the films of ink will vary, making one or other of the colours predominant. This will, of course, falsify the original and give spurious harmony: a glow of red, yellow or blue, or a mist of grey which subdues all colour and deepens all tone.

Next time you visit a gallery, buy a colour reproduction of one of their paintings and compare it with the original. If the red was over-inked and is too heavy, the reds will be too strong, pinks will be turned into red, blue will be violet, green will

be dulled and brown, yellow will be orange. A warm haze spreads over the whole print.

If the yellow printing was too strong it will turn red into orange, violet becomes brown, blue turns green and what was grey in the original looks khaki.

Or there may have been too much blue ink. The red will turn cool and purple, grey will be turned into blue, yellow into green, and pink into mauve.

A too-heavy film of black darkens and dulls all colours. Orange and red become brown, yellow becomes olive-green.

There are all sorts of other possibilities. More than one colour can be over-inked. One plate can be under-inked and starved of colour, nearly eliminating its contribution to the general scheme. With little or no red, for instance, there can be no violet, brown, pink or orange. Or all colours can, to varying degrees, be over-inked, eliminating pale and subtle colours. The possibilities are innumerable.

A painting I did of Hexham Abbey, as one in a series of advertisements for Shell petrol, has recently been reproduced in a variety of publications. In every one of these the colour was wildly different. The general quality of the printing made little difference. Not one of them came anywhere near the colour of the original.

These vagaries of colour-printing teach several lessons. The most important is: look at originals whenever possible. They also show how interdependent colours are—the extent to which they affect each other. And the fact that these distorted prints are often more harmonious than the originals makes one wonder about the importance of harmony in a work of art.

You may feel now that it is no great loss that the following examples are not illustrated in colour.

No artist can work in a vacuum. We are all influenced by what we see around us. Painters are influenced by what other painters do and what other painters did before them.

The colours we see and use, the effects in nature we try to convey, the things which inspire us and make us want to paint; all these reactions are conditioned by the traditions we respect and the influences and conventions we absorb—many of them unconsciously. It is as well to know as much as possible about the forces which inevitably shape our style and vision.

This can be no more than a short list of important developments in the use of colour.

Fig. 54 Detail from mosaic in San Vitale, Ravenna

Right at the start of Western painting is one of the most power-ful and colourful schools—Byzantine painting and mosaic. These mosaics in particular are important to us, because of their use of colour. Each *tessera*, usually opaque coloured glass, provides a separate accent. Areas are broken up. No two *tesserae* are exactly the same colour. Each is set at a slightly different angle, catching and reflecting light in varying degrees. Uneven opacity of the *tesserae* adds to the liveliness. Hieratic stiffness of design contrasts with the sparkling, flickering surface. The technique of using tiny points of varied colour to create an illusion of form and light was not used again before the Impressionists.

Seventeenth-century Dutch and Flemish still-life painters were meticulous, bland and impersonal. Yet their flower paintings show an awareness of the part played by colour, which only now is being emulated by abstract artists. To please their philistine clients they painted in elaborate detail and hard finish. This makes it difficult to convey depth and atmosphere. So they used colour to give a sense of recession to their work.

The flowers on the edges of their bouquets (those farthest away from us) are often blue, pink or violet—i.e. cool, receding colours. The flowers nearest us, in the centre of the bunch, are red, orange, yellow—warm, advancing colours. Over-coming the stiff and formal design, it is the colours of the flowers themselves which give movement and space to the work.

To Rembrandt light was a positive power, overcoming darkness, revealing colour and texture. Painters who use great tonal con-trast usually sacrifice colour. But Rembrandt's sonorous harmo-nies of red, yellow, orange, grey and brown glow with a jewelled richness. The texture and density of each touch of paint (apart from what it represents, an eye, a finger or a bit of fur) is a unit in the elaborate patchwork of tone and colour.

Only in the 17th century was landscape accepted as a subject. To us, changing colour, atmosphere and light are the obvious aspects of landscape. Yet before Turner, in the first half of the 19th century, landscape painting was a matter of formal composi-tion and tone. For Turner light and colour were synonymous. Fluid, swirly colour dissolves form. Newton's discovery of the divisibility of white light inspired him. White is often the nucleus of bursts of spectral colours. The evening sky of pink-edged indigo clouds, against a pale yellow and green sky, so frequent in England (I'm writing this from observation at this moment), was used by Turner as a young man. It became the foundation of his later

Fig. 55 Rembrandt, portrait of Jacob Jacobsz Trip (detail). National Gallery, London

Fig. 56 Turner, Snowstorm, Steamboat off a Harbour mouth, 1842. Tate Gallery, London

adventurous work in oils.

He never used dark, tonal landscapes as foils to bright skies. Colour diffuses the whole painting and the whole painting glows and vibrates with related hues.

I don't think we should try to copy the more garish effects of nature. But if, like Turner, we can use them as inspiration and a starting point, the result can be fine.

The French Impressionists greatly admired Turner and were influenced by him. Where Turner was instinctive, they based their work on scientific colour theories. They searched for positive colour in shadows, complementary to the colour in light. Colour at the expense of solidity and structure; an intense awareness of atmosphere; fragmentation of detail and outline; stressing of primaries, red, yellow, blue—these are the things which characterise their work. In contrast to the academic teaching before their time, they put down the colours they wanted directly, rather than building them up gradually with dead-colouring and glazes.

Cézanne, not strictly an Impressionist, used colour to give pictorial solidity and classical balance. Many of his works are based on the complementaries orange and blue. Advancing forms lean towards orange, retreating ones towards blue.

If any one artist can be called the father of modern art it is Cézanne.

Gauguin and Van Gogh used colour emotionally and decoratively. They were the first painters to use the colours of the spectrum in full strength, unbroken by tone. Strong, pure colour is now so accepted that we find it difficult to realise how shockingly crude and revolutionary it must have seemed 90 years ago.

In contrast, Seurat based his paintings on scientific colour division. His Pointillist theory split all colours into their component primaries. Colour is not mixed on the palette, but tiny dots of pure colour combine when seen from a distance. Seurat was so methodical that, having decided on the exact proportions of the coloured dots in any given area, he could continue work by artificial light, distributing them according to a plan—so many of each colour to the square inch. My drawing, figs 20 and 41, is an attempt at a kind of Pointillism.

Around 1905 a group of young French painters, Vlaminck, Braque and Derain among them, called themselves *Fauves*— wild beasts. In their work they used colour agressively. They tried to shock, to exceed all bounds. Heavy brilliant outlines clash with flat areas of pure pigment. Often they used the exact opposite of the colour one would expect—red meadows, orange skies, green roofs. Yet their subjects, nearly always landscapes and seascapes, are not wild or shocking. Theirs was a short-lived, but fruitful movement. Much of today's art stems from its liberating influence.

To the Expressionists, Kokoschka, Nolde and Soutine among them, colour expressed personal feeling. The tortured writhing of their graphic work has an equivalent in heightened and intense colour. Every picture is a personal drama. Harmony, balance and repose is their antithesis.

Paul Klee was the most important artist who came out of this movement. Imaginative, inventive, witty, his art is highly civilised. He was an accomplished musician and his colour theories are closely linked to theories of musical harmony and composition.

A recent abstract movement, the Hard-Edge school, which originated in the U.S., has affected our way of seeing. Theirs are large works with precisely painted simple areas of flat colour.

Fig. 57 Monet, Water lilies (detail). National Gallery, London

Fig. 58 Cézanne, Mont Ste Victoire. Courtauld Institute Galleries, London

Acrylic paint is often used and it may be applied by spray, rather than brush, to give a flat, impersonal effect.

One of Ellsworth Kelly's paintings is a brilliant red rectangle taking up most of the canvas, leaving only a slightly irregular, narrow border of white all around. In a work like this the intention is to let colour speak for itself, declaring its power, density and whether it advances or retreats. The paintings reaffirm in simple terms facts about colour balance and harmony. They do so hypnotically, partly at least because of their enormous size.

Kinetic art brings us full circle. What began with Sir Isaac Newton in the laboratory, has now become the artist's concern. Moving lights, mirrors, prisms, refracting liquids, ultra-violet and infra-red light beyond human vision, and the physiological phenomenon of persistence of vision are the Kinetic artist's vocabulary.

Fig. 59 Klee, Polyphonie, 1932 (detail). Kunstmuseum, Basle

Index

Acknowledgments

Thanks are due to Mr. and Mrs. G. Isaaman for kind permission to reproduce fig. 47, and to Messrs. Winsor & Newton for allowing me to reproduce parts of *Notes on the Composition and Permanence of Artists' Colours* and in particular for providing the artists' materials used for the frontispiece and figs 17, 18, 21 and 23. Figs 55, 56 and 57 are reproduced by courtesy of the Trustees, The National Gallery, London. For fig. 58 thanks are due to the Courtauld Institute, London, and for fig. 59, Paul Klee's 'Polyphonie, 1932' © by S.P.A.D.E.M., Paris, to the Kunstmuseum, Basle.